Gue-rilla Art

Edited by Sebastian Peiter

With additional text by
Goetz Werner

Laurence King Publishing

LAURENCE KING

Published in 2009 by
Laurence King Publishing Ltd.
361–373 City Road
London EC1V 1LR
United Kingdom

T: 020 7841 6900
F: 020 7841 6910
e-mail: enquiries@laurenceking.com
www.laurenceking.com

URBAN CANYONS

© 2009 Urban Canyons Ltd.
Edited by Sebastian Peiter

A catalogue for this book is available from the
British Library.

ISBN: 978-1-85669-593-0

Design and cover art by Ollystudio

Printed in China

beyond this point

From Urban Canyons to Auction Houses

After producing classic arts documentaries on Young British Art and a number of old masters, I first recognized the street art phenomenon while filming the *URBANATION* television series between 1999 and 2003, covering the youth culture underground in London, New York, Paris and Berlin and featuring Futura, Invader, Ramm:ell:zee, Zevs and many other artists in this book.

Here was a new generation of young artists who were strongly supported by their peers across the world, but totally ignored by the mainstream art galleries. The emergence of Bristol-born artist Banksy made London at the turn of the twenty-first century the focus of a new international art movement that had originated in New York's graffiti scene. Banksy's satirical works quickly found admirers in the media and advertising world, attracting galleries and Hollywood star buyers.

Unlike the established graffiti stars of the early 1980s like Keith Haring and Jean-Michel Basquiat, the artists of this new movement developed into a range of styles and working media outside the gallery system and have been constantly pushed forward by new ideas from the US, Europe, South America and Asia. Since the end of the 1990s, most of these street artists have travelled the world, organizing shows in small galleries and trend stores and leaving a visual presence on the streets wherever they go. They see themselves as part of an urban art that subverts the dominance of the advertising that pollutes the landscapes of our cities.

This emerging group of artists found early recognition and support in a network of alternative lifestyle publications like *Lodown* and *Tokion*, as well as in those dedicated to the scene: *Wooster Collective*, *Graphotism*, *ONtheGO* and the more recent *Swindle*. Following the grassroots buzz were the corporate clothing and merchandising design deals pioneered by the ingenious Futura and his business partner Stash. Then came the alternative gallery spaces like Deitch Projects and Alleged (New York), The Luggage Store (San Francisco) and Elms Lesters Painting Rooms (London), which helped the slow crossover into the art world. Early art patrons included the Parisian fashion designer Agnès B, who has supported new talent for many years. There are also many committed individuals who have grown out of the graffiti scene itself, like Adrian Nabi, the Iranian-German

curator of *Backjumps* magazine and exhibition series, the Manchester-based Michael Anthony Barnes-Wynter and his Doodlebug showcases or the most influential of all, Steve Lazarides, the London-based cultural entrepreneur who helped to put street art in its fully deserved place as a recognized art form.

Since 2005, a surprised underground scene has witnessed a worldwide art boom, with street artists now included in contemporary art auctions on a regular basis, and art institutions like MoMA (New York) and Tate Modern (London) putting on street art shows to attract new young audiences. This sudden surge in interest is very different from the last London-based art boom, that of Young British Art, in which one dominant art dealer (Charles Saatchi) controlled the careers of many new artists. As part of a democratic artistic community with a massive internet-based following, this accessible generation of street-inspired artists can always revert back to their roots, selling prints and customized merchandising to their peers.

Most artists and alternative gallery operators in this book agree that there is only a very limited number of artists who will make the long-term crossover into the mainstream art world. Apart from producing new and challenging work they also have to learn to play by the rules of the market. Street art, with its anti-government and anti-corporate origins, is not the ideal bedfellow for the art business, which increases demand by limiting output. Street artists will always create illegal prints, have work ripped off city walls by collectors or create a quick freebie for a friend. Art print distributor Pictures On Walls (POW) recently had to certify original Banksy and other prints because of a flood of unauthorized reprints. Even an enlarged screen still from the original *URBANATION* television series of the artist Zevs attacking billboard posters in Paris has surfaced as a limited-edition print at a gallery in Paris.

One thing that unites this diverse new generation of artists is their reluctance to be classified as 'street artists'. Having completely outgrown, or never even participated in, name tagging and bombing of public transport systems, most of them prepare international exhibitions in studios and see their work traded at art auctions and galleries. I named this book and the original documentary *Guerilla Art* because what really makes these emerging artists different is their uncompromising attitude that does not rely on highbrow art references, but instead on humour and anarchy. They can be anti-corporate and at the same time suck the corporate tit when it suits them and it is this 'take no prisoners' attitude that earns them the 'guerilla' moniker.

Sebastian Peiter

This book is dedicated to Denise, Celeste, Eva and Thomas.

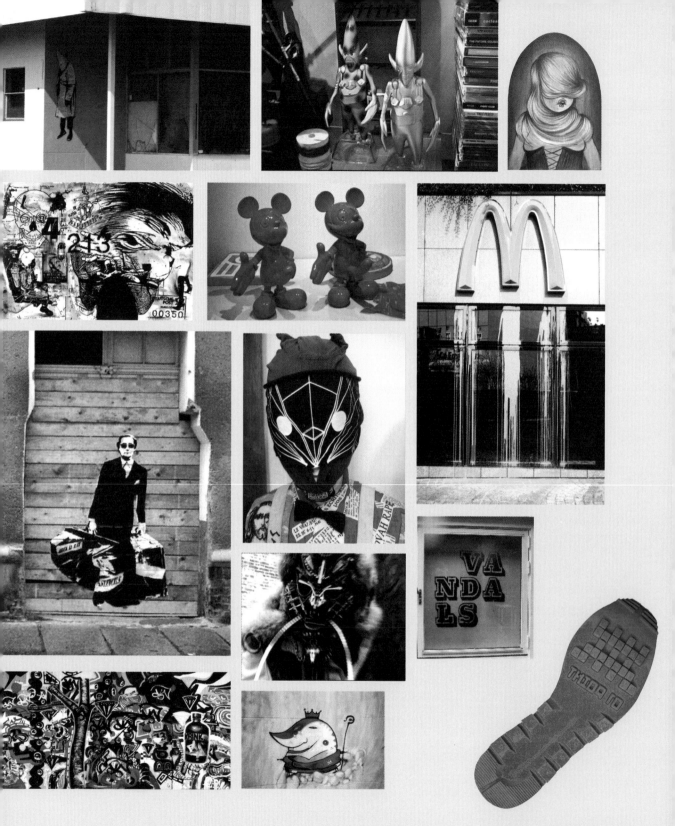

Over the last few years street art has established itself as an internationally recognized art form. But where can this street-inspired movement go from here? Works by Banksy have been boarded up and chiselled off walls to be sold on eBay for money far exceeding the gallery prices. So, even though street art has resisted being sucked into the mainstream, like all radical or avant-garde movements, it surely will be.

amm: ell:zee

The New York graffiti sprayer, sculptor, rap musician and performance artist Ramm:ell:zee is one of guerilla art's true pioneers. For his edgy art happenings, Ramm:ell:zee has created a personal mythology of his own gods, based on science fiction, horror and even quantum physics. His paintings, costumes and art objects are made from throwaway materials found in skips and on the streets of New York. They have become collectors' items for hip hop fans and art lovers across the world.

Ramm:ell:zee made his name in the late 1970s, painting subway trains with Ink76, Dondi and Doctor Revolt, and was discovered by a larger audience in 1982 through the cult movie *Wild Style*. With his 'Beat Bop' track, Ramm:ell:-zee has been widely credited for coming up with the nasal polyrhythmic vocal style now associated with artists like Cypress Hill or the Beastie Boys. Ramm:ell:zee was also a member of the recently re-formed Death Comet Crew, performed with the Gettovetts and released his debut album *Bi-conicals of the Rammellzee* in 2004.

www.gothicfuturism.com – Interview Eva Sonaike / Goetz Werner

Opposite – Performance by Ramm:ell:zee as Shun-U the Loan Sharker from his Gothic Futurism mythology.

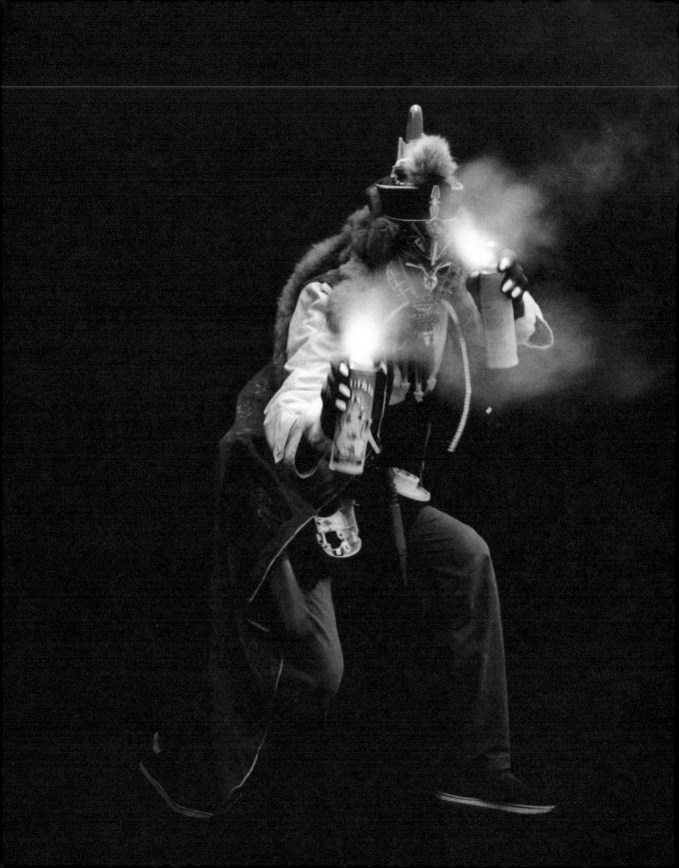

The long hours spent in compression chambers as a diver for offshore oil rigs and his deep-rooted connection with hip hop culture helped this maverick innovator to come up with the Gothic Futurism mythology. In his Ikonoklast Panzerism theory, Ramm:ell:zee describes a battle between letters and the symbolic warfare against any standardizations enforced by the rule of the alphabet. Ramm:ell:zee was one of the first hip hop artists to recognize how writing is used as a tool to keep outsiders at bay. His theory questions the role and deployment of language in society, harnessing words to give them the power of a weapon.

Ramm:ell:zee expresses his study of what he calls the Dictionary's Language Tree through paintings, resin frescoes, drawings, sculptures, embroidery and a complete fleet of 'letter racers'. His performance art includes the

re-enactment of his theories in his self-designed masks and costumes. Ramm:ell:zee has exhibited in galleries and alternative art spaces across the US and Europe. Despite doing the odd piece of commercial work, he has never made a career in the traditional sense out of being one of the most visionary guerilla artists ever. But then again, when you read the sign outside his apartment door, 'Whoever dies with the most toys wins!', you know that for him it's about something else entirely.

The graffiti artists of the 1970s in the tunnels of New York continued where the monks of the fourteenth century had left off with their illuminated letters. Back then handwritten religious scripts were the main way to spread any form of knowledge. Those monks, who were fighting with the clerical elite, started

to decorate the letters with ornamental outlines so they could illuminate the truth in the core of the letters. These letters are electromagnetic structures and as fonts they represent pure knowledge. In order to protect this knowledge the monks sent the letters to a place where the clerical elite wouldn't dare to go: hell. That's where they stayed until, in the early 1970s, the first graffiti writers rediscovered them in the gothic tunnels of the New York transit system.

We called them rolling pages that had car numbers or year numbers. These particular trains would be switched around. If the A train was switched to a D train by subway masters, and you had two or three names written on it like 'wink', 'wealth', 'die', if they got matched up with an IRT car, you would end up having an iconic statement: 'Wink, Wealth, Die'. None of the writers actually did this on purpose, but it was the

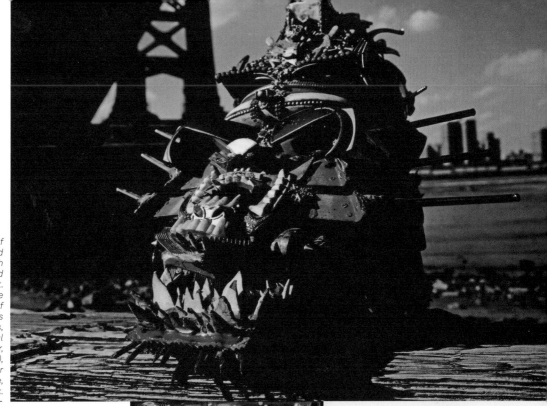

Opposite – One of
Ramm:ell:zee's mixed
media works into which
he inserts objects found
on the street.
This page (clockwise
from top) – One of
Ramm:ell:zee's
machines,
performances as Vocal
Wells God (Chimer,
the Galactic Bookie),
as Chaser the Eraser
and as Vain the Insane,
mixed media work.

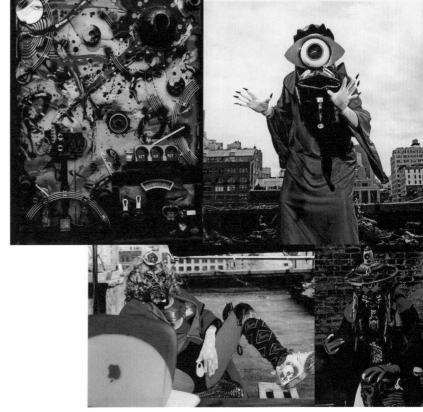

subway commanders switching the train
cars, the train pages, who made these
sentences roll. So you had the biggest
book on the planet.

When letter races were invented in
the subway tunnels of New York City,
we had a battle between presidents
and assassins. The assassins won, the
presidents lost. Writing on walls was for
toys. Ironically, those who wrote on the
walls could not advance to presidency
and they thought an assassin was not
necessary. They were called bombers,
and bombers simply did not have the
skills because they weren't taught. They
wanted to sit in the fame of their name,
whereas we were the hidden; we were
the silent. We'd just kill you because you
were president, nothing more – letter
races, simple as that.

In the beginning we talked a lot about
how proud we were to be who we are,
and economically we were liars about
how famous we were, when we were

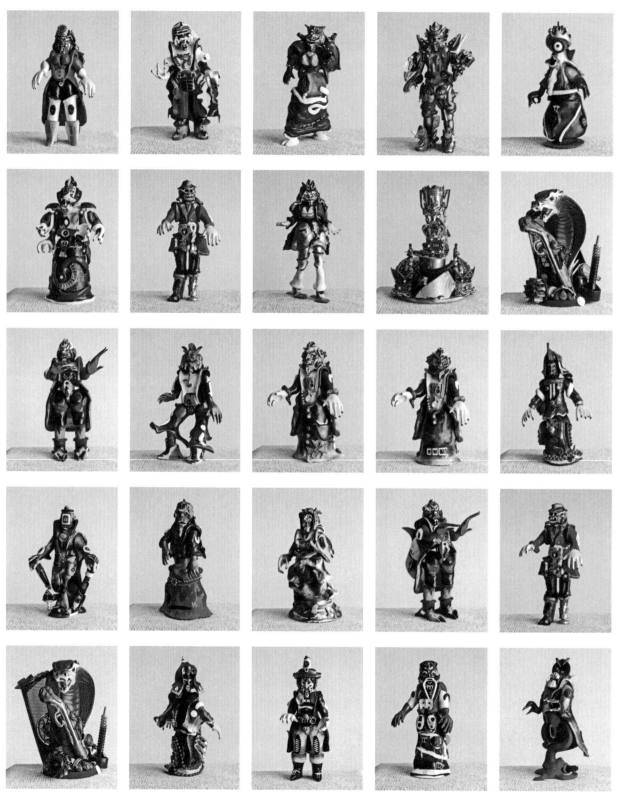

still in the projects. Now many of us are millionaires and we don't lie no more. We still have this goading about houses, cars and girls. Most people would prefer themselves to be this pimp-type cavalier. But we need to talk more science; we must remember that there is space travel. Get these things out there, create fear. Fear is always good. Most people don't think in this culture. They are too busy listening to the homage to this guy's dick size or this guy's love of girls or how much girls love him or what a beautiful car looks like. It's like forget about the car; I build tanks. I don't worry about cars. You have to switch it now. It's got to change because there's a need for futures, whether they be gothic futures or not, you have to move it.

My favourite form of expression – performance art. What I'm doing right now. Painting is second dimension trying to get into the third. Performance art – that's third dimension trying to get into the fourth. You can die as a painter, but to die as a mechanic, that's a whole lot better. I am the hidden, I like being hidden. Many people think I actually want to be seen, but I'm not interested in fame. I like infamy. Infamy is best for me. I walk down the street, and people look at me and say: 'Who the hell are you?' I'm just an average Joe, but Ramm:ell:zee is an equation, it's not a name. That's what made me infamous – I'm one of the few people that have an equation.

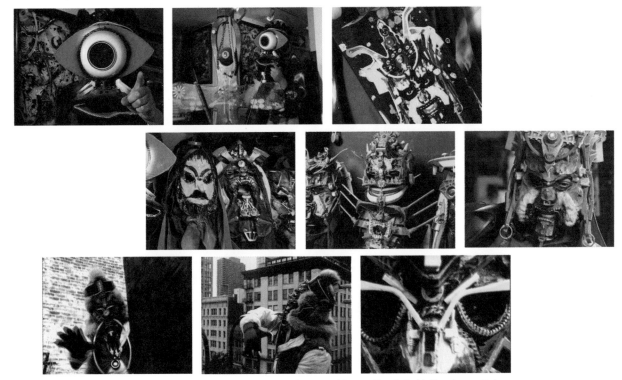

Opposite – *Figurines of Ramm:ell:zee's Gothic Futurism mythology.*
Above – *Ramm:ell:zee in his New York studio, and performing on the roof of the studio's building.*

utura

New York-bred Futura was one of the original writers who invented graffiti art from New York's emerging hip hop culture in the 1970s. Born in 1955, as a GI he narrowly missed combat action in the Vietnam War. When Private Leonard Hilton McGurr returned to the Big Apple, he put his military skills to good use by trespassing in the yards of the Metropolitan Transport Authorities, bombing trains and city walls with other artists such as Ali, Duro and Dondi. In the early days of graffiti, Futura developed his distinctive style. While most writers focused on lettering and elaborate name tagging, Futura pioneered an abstract spray-paint approach with aerosol strokes as thin as airbrush lines.

Futura's authentic and dynamic street style opened up a successful stint in the art world, where he was represented by Agnès B's Parisian gallery. His street art canvases gained mainstream potential beside those of fellow artists Keith Haring, Jean-Michel Basquiat and Kenny Scharf.

www.futura2000.com – Interview Sebastian Peiter / Damien Saracin

Opposite – Futura and his toy collection in the Project Dragon studio, New York.

After transformation from vandal to one of the hippest artists of New York's East Village Movement, Futura moved on to become one of the most influential and acclaimed graphic artists in the world. Recognizing the computer as an alternative medium to canvas and spray can, Futura lost his '2000' tag and started challenging contemporary art forms by working as an illustrator and graphic designer in the 1990s. He became involved with legendary punk rock group The Clash and designed the sleeves for their single 'This is Radio Clash' (1981) and the album *Combat Rock* (1982). A chance meeting with Mo' Wax label head honcho James Lavelle in 1992 gave Futura a new direction. He created the artwork for numerous label releases and produced the imagery and merchandising for the UNKLE project. Over the years Futura got involved with numerous legendary streetwear and skater brands such as GFS, Zoo York and Subware. Futura runs his own Project Dragon and Recon clothing lines from a shared workspace with fellow New York artist Stash. Futura can also claim to have started the vinyl toy craze with his highly collectible toy figure and merchandising designs for UNKLE, Nigo's A Bathing Ape label and others.

To date, Futura's unique style and neverending creative output still combine his love of the abstract form with a keen interest in future technology, popular culture and fascination with military imagery. But while Private McGurr has been many things to many people – graphic design icon, toy designer, fashion label founder, painter, bike messenger, postal worker and even Madonna's boyfriend – he is still best known as Futura, the legend who started a world phenomenon with a Krylon can.

The *2001: A Space Odyssey* movie was my inspiration. I would have been Futura 2001, probably, but that's too obvious. I am from another time really, born in 1955. My first impression of the new world was the 1964 World's Fair. This gave me that vision. They were projecting the future and a few years later *2001: A Space Odyssey* comes out, then a man walks on the moon. As a human I have moved beyond what I was once doing as a teenager. I am still more or less the same person but I am just using different media right now to express myself – more contemporary media, more media of information exchange that we didn't have so many years ago. I have been fascinated with technology, gadgets and what's becoming a micro electronic universe with all these new digital toys that are coming out. Beyond that I am someone I think who is forecasting the future. Maybe my name Futura 2000 sounds really clichéd now, but when I was fifteen and I invented the name, it was very romantic. I am still looking beyond to the next year, for what I can do in the future. My whole identity has been science fiction/fantasy based; I am a dreaming type person. I see myself as an older man, still doing interesting things, hopefully; being influential even in the future, but more importantly fulfilling my dream to my family and being there for them. I have been very fortunate to have transcended the life of a graffiti writer in NYC to become a graphic artist, a painter, a toymaker, whatever.

Project Dragon is myself and Stash. Recon is our first shop that gave us a chance to have some control over our own distribution locally and get other brands in from friends. The meaning of Recon is based on the word 'reconnaissance'. 'Recon' – as in a unit that is out in advance, taking a visual assessment of the situation and then reporting back to headquarters. The name, although it has military implications, can translate over to civilian society – your advanced people out there checking things out before you get there.

It would be presumptuous to say that my works are hanging in museums and galleries. I was never really quite on the level of a Keith Haring or a Jean-Michel Basquiat or other known 'graffiti writers'

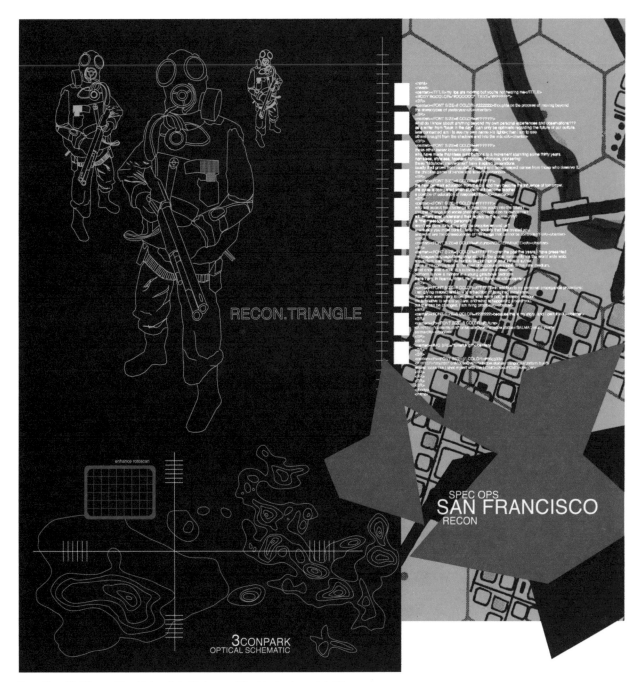

RECON.TRIANGLE

enhance rotoscan

3CONPARK
OPTICAL SCHEMATIC

SPEC OPS
SAN FRANCISCO
RECON

Opposite – Clothing and New York outlet of Futura and Stash's streetwear label Recon.
This page – Futura design work for Lodown magazine. From Marok (Thomas Marecki),
Schizophrenic – Lodown Graphic Engineering Part II, *Berlin: DGV, 2000 (ISBN 3-931126-41-2).*

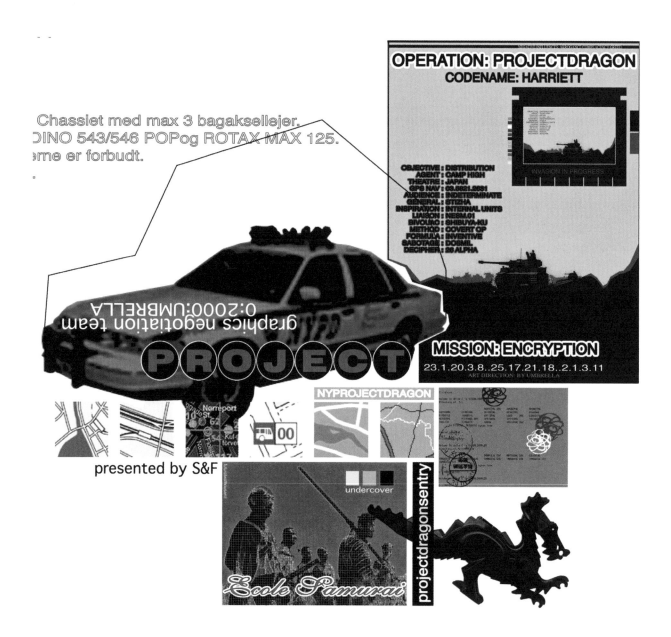

OPERATION: PROJECTDRAGON
CODENAME: HARRIETT

INVASION IN PROGRESS

OBJECTIVE : DISTRIBUTION
AGENT : CAMP HIGH
THEATRE : JAPAN
GPS NAV : 09.5821.2631
AUDIENCE : INDETERMINATE
GENERAL : STIZHA
INSPIRATION : INTERNAL UNITS
LIAISON : NESM.01
BIVOUAC : SHIBUYA-KU
METHOD : COVERT OP
FORMULA : INVENTIVE
SABOTAGE : DOSMIL
DECIPHER : 26 ALPHA

Chassiet med max 3 bagakselleier.
DINO 543/546 POPog ROTAX MAX 125.
ørne er forbudt.

graphics negotiation team 0:2000:UMBRELLA

PROJECT

MISSION: ENCRYPTION
23.1.20.3.8..25.17.21.18..2.1.3.11
ART DIRECTION: BY UMBRELLA

presented by S&F

NYPROJECTDRAGON

undercover

Ecole Samurai

projectdragonsentry

or 'street artists' from the 1980s. I never got that push, and I couldn't care less really. If I am doing an exhibition in a gallery, what kids in a neighbourhood are really going to go to that? That whole scene of exhibiting in a gallery and being a painter, I am done with that. I don't really want to make money that way, or expose myself in that way. That is what I did then and it was a learning process for me. I am not trying to put artists off who want to pursue that, but it's certainly not something that I am trying

to do right now at this moment or in the coming years. I have got to choose a way to be clever enough to make money, aside from my creative impulse to be this communicator.

I am fortunate because I am in this autonomous universe of which I am totally in control. I don't have to check with people to see if they think an image looks cool. I am a bit like a graphic gangster/gunslinger – I have the ability to whip out my hardware and punch a

hole in things. I am doing hit and run things like that. The whole graffiti thing is very self-centred and I am a bit tired of that. I was certainly more of a loner and an individualist – a one-man-show when I was younger. Now I have evolved into this player who can be an asset to a team; take me on board and let me do my own thing. I do it quickly and then I get out. I am a professional in a militaristic operational kind of a way, in terms of the way they are very productive. I do have a kind of military philosophy. I had

four years in the military, so I have been trained by my government to understand how to get a job done for real, playing with million dollar toys. So I can do your graphic logo or I can arrange a little group get together. My organization and operational skills are like second nature to me. I am not overwhelmed by the tasks in this civilian society. It's pretty simple to live out here if you have any kind of brains.

There's a new crop of graffiti writers – pure spray-painters, guys who are just taggers. And there's also a new level, a new movement of street art, people like Twist, Phil Frost, Kaws – guys who are doing that street art thing a bit differently than the way we did it back in the day. It's to be respected what European artists have done with the initial graffiti style that was imported to them in the 1980s. Writers from Europe are some of the best in the world in terms of painters, because they developed the style that had already been created here and were able to look and adapt it to different lettering styles that they liked. At the same time, a lot of graffiti from New York back in the original days was not from very good artists. They were just raw taggers, piecers, guys that were just into bombing. A lot of the new people who transition to street art or graffiti are good illustrators, good painters and for them to make the move to spray-paint is just learning how to use another artist's tool. To me, back in the day, the thing that defined us was our medium – our spray can. Now it's developed way beyond that. People are doing public works with paint, spray-paint and airbrush. It has become more developed, more refined. In New York it is less developed. The numbers of people doing it are certainly less than you would find around the world. For New York to be the Mecca of that movement is ironic; in fact now it's kind of a lost city in terms of the history of it. It's more of a: 'Wow, remember?' It's reminiscent; it's almost nostalgic. We are living on memories here. There's a lot of New York graffiti artists who are doing it, but it's different when you are not able to put pieces up on subway cars. That's part of the mystique of what really made it so fascinating. That's also

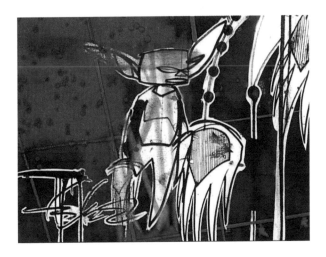

why they had to kill it, because you can't have your subway system out of control, like the way it once was. It's funny for me, I have become almost part of the establishment that I was against when I was a kid, but then again that happens too, sadly. I still like to see it though, depending on where it is obviously. That's one of the problems I used to have in Paris. Those kids would just bomb anything. I remember the Louvre metro station that was so beautiful, and they just killed it. That was sad because it sends a message to society that this is terrible and we can't allow it. It's always bad apples that spoil the bunch. The negativity of the graffiti movement is the one reason why I have to separate myself from it because people look at you in a different light. They associate you with something that's a detriment, a liability, certainly not good, and definitely not politically correct.

I am a big toy collector: Devilman, Star Wars, GI Joe, 12-inch military based market, Bruce Lee. There are so many toy variety possibilities. I've got into this whole collectibility thing. That's what I do. It's like a bit of a passion; it's something you've got to have real emotion about. And I think it comes from having a limited amount of toys as a child. I didn't have the economic means to have those things I really wanted, but lately I have overcompensated because I've got way too many toys.

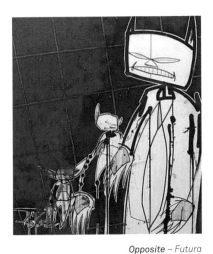

Opposite – *Futura design work for* Lodown *magazine. From Marok (Thomas Marecki),* Schizophrenic – Lodown Graphic Engineering Part II, *Berlin: DGV, 2000 (ISBN 3-931126-41-2).*
This page – *Futura canvas of his UNKLE character exhibited at Elms Lesters Painting Rooms, London.*

lek
Le Rat

Blek Le Rat is the founder of the popular stencil technique that has allowed the street art pioneer to spread his monochrome images in large numbers around the world's urban canyons. The Paris-based artist named himself after Blek, the eponymous hero of an action comic he regularly devoured in his youth.

Blek Le Rat's work has had a strong influence on the new generation of street artists – especially Banksy, who adopted Blek's trademark rat stencils and the socio-political comment that Blek Le Rat's work often makes.

Blek Le Rat's street imagery has only recently made the long overdue transformation from wall to canvas. His stencils of an American soldier in Iraq, French hostage Florence Aubenas or Michelangelo's David with an AK47 communicate political messages to the public in a subtle way. The stencils of Blek travelling with suitcase and sheep, the urban spaceman and Joseph Beuys as a beggar reveal a lighter side to his art, as does a series of self-portraits that includes a gun-toting Warhol-style Elvis.

Blek is a family man. His wife and son accompany him around the world from his idyllic studio on the outskirts of Paris. His wife, the photographer Sybille Prou, has published a photography book on her husband's work.

Interview Sebastian Peiter / Photos Sybille Prou

Opposite – American Desert Storm Soldier stencil on London rooftop (Blek himself is the shadow cast on the wall).

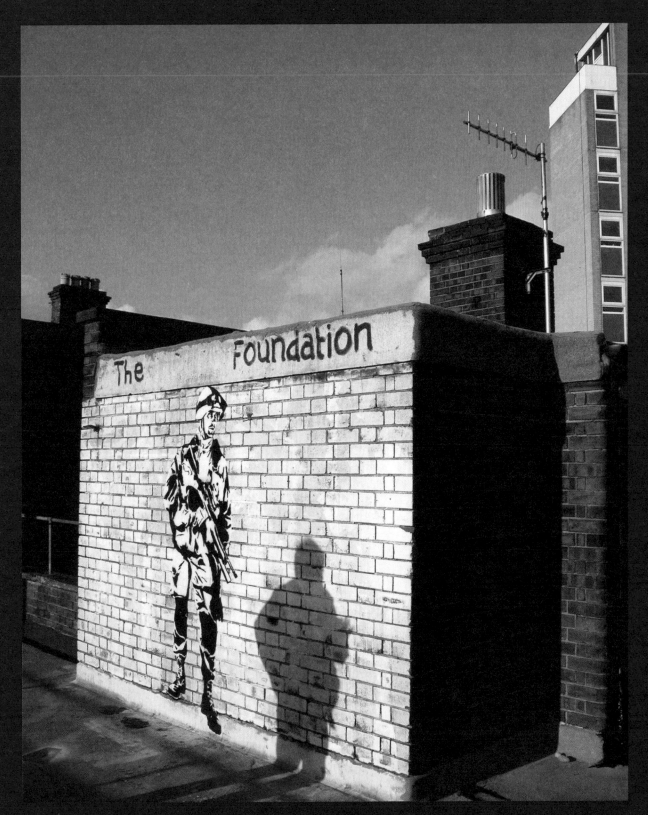

discovered the stencil technique in Italy as a child in 1962 or 1963. I was in Padua during a vacation with my parents. On the walls I saw some faint Mussolini portraits painted with stencils. I really remember it like yesterday, when I asked my father what it was. I didn't know much about the Second World War. It was a Mussolini portrait in profile with a helmet. I forgot about it, but it stayed somewhere in my mind. When I started to make graffiti, I remembered the image that I saw in my youth.

In 1971, I first saw graffiti in New York, but I didn't have a good technique. It is very difficult to spray freehand on walls. At the time no one was making graffiti in Paris. I was alone. The city belonged to me. I tried one in Paris and it was a horrible piece. So I told myself maybe you can do something with stencil. My first stencil was a small rat. I sprayed it

on the walls, everywhere in the streets. I like rats because they are wild animals in the cities and the rat mythically brings the plague. Graffiti is like the plague because when you start you can't stop and you pass this on to others to do the same. Also in 'rat' you have 'art'; it's a connection.

One of the first images I did was of an old man screaming in the street. Actually, he was an Irish guy screaming at some soldier. It represents a kind of iconic image. I wanted to be a man like that, very brave, very courageous. When my wife was pregnant, I used to make a woman holding a child or stuff like that – always a connection with my life.

I want to have a social message for people. I really appreciate it when someone comes and draws or writes something over my images. I want to have interaction between me and the

others. When I started, I was really alone in my studio. I did not talk to many people. I knew that working on the street, the very next day thousands and thousands of people would react to my image. It gives me the strength to keep doing my work.

I don't like to call it 'street art'. I prefer 'urban art'. Urban art is the future of art really. For over 25 years now there has been no city in the world without graffiti. It's the most important movement in the history of art. I really believe this. Even more important than pop art, because there are so many different pieces done all over the world. Every city has its own graffiti artists. Even in Beijing you can find some artist making sweet urban art. The difference from a 'fine artist' working alone in his studio is that you take a big risk when you work in the street. You can go to jail. You can pay big fines. These artists are very involved. For me they

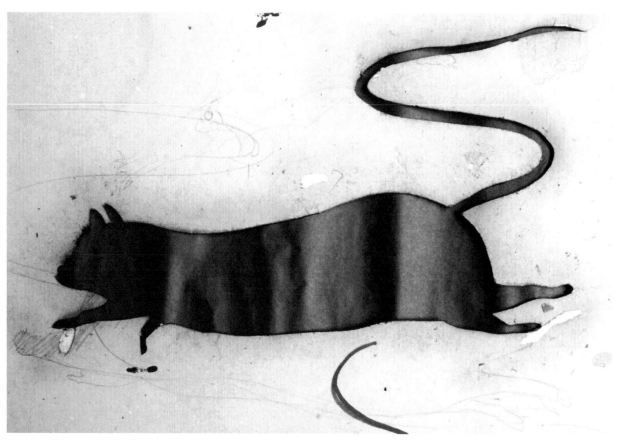

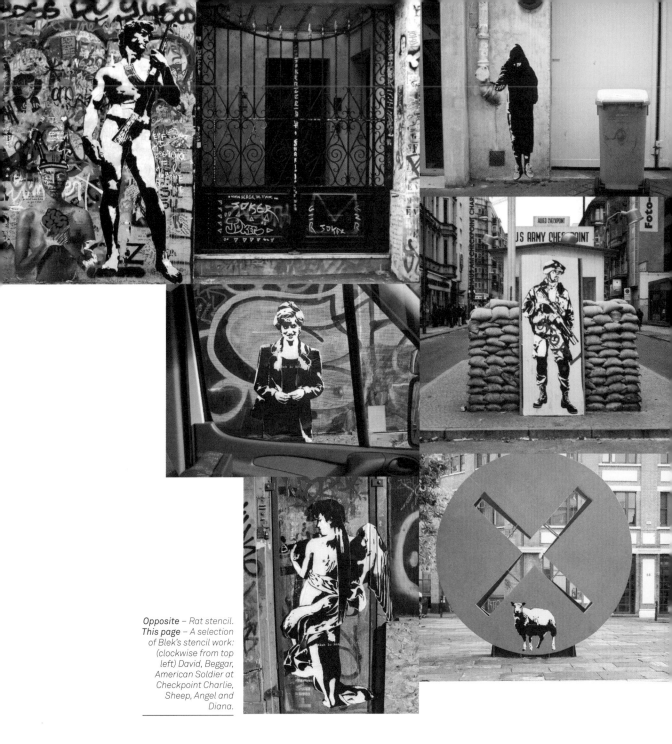

Opposite – Rat stencil.
This page – A selection of Blek's stencil work: (clockwise from top left) David, Beggar, American Soldier at Checkpoint Charlie, Sheep, Angel and Diana.

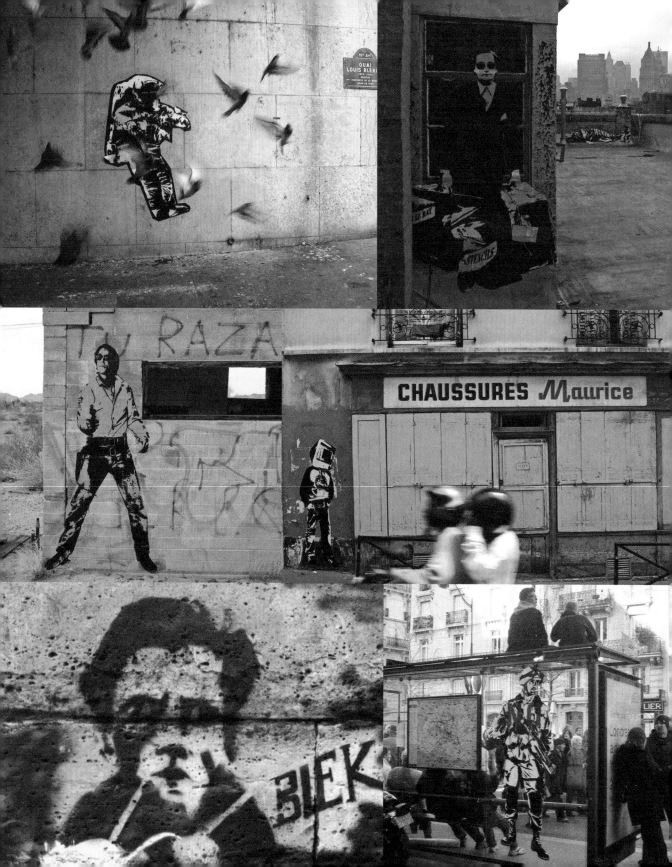

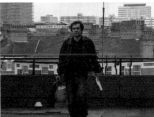
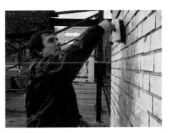

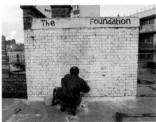
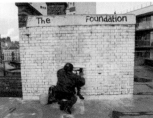
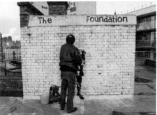

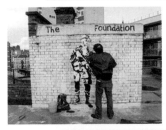
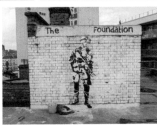

Opposite – *More examples of Blek's stencil work: (clockwise from top left) Astronaut, Self Portrait, TV Man, American Soldier, Blek and Rats and Cowboy.*
This page – *Blek Le Rat pasting up the American Soldier stencil on a London rooftop.*

are the true artists. It is very difficult to make a living with this art because it's a free art. To be in the street is a great way to get famous very quickly. But it doesn't mean that you make a lot of money. Some artists can live off their street-based art, but most do other jobs. Many use urban art to get into a gallery. When they find a good art dealer, they can be pushed quickly to the top. Keith Haring was working with Tony Shafrazi. Now there are other dealers. The art market has not changed a lot since those days. It works with the Stock Exchange. When the Stock Exchange is very high, the art market is high too. When the Stock Exchange is low, the art market is low. It's a market like any market.

The work in the street is ephemeral. It only stays for a few weeks or days. Gallery works are a memory of what happened before in the street. My life is in the street. I have done it for 25 years now. I get very paranoid about the police and people who don't like urban art. I would much prefer to be free and work where I want. But when you are an artist and you do a piece of art, you want to leave something for the future – that's the most important thing. I really think that we are still at the beginning of this art form.

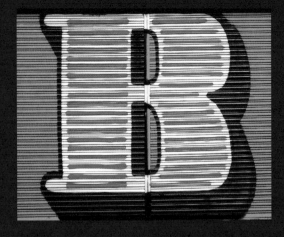

anksy

Banksy has become the world's most infamous guerilla artist. His blend of humour and political satire, his media savvy and anonymity made the London-based stencil artist popular with a worldwide audience new to street art. Although there are rumours of an advertising industry background or a privileged public school past, there has never been definite proof of the identity of Britain's most notorious 'vandal'.

Originally from Bristol, where he was born in 1974, Banksy typically crafts his images with spray-paint and cardboard stencils. Around 1993 his monochrome graffiti started appearing in and around his home city. By 2001 he had taken his trademark stencil images of urban outsiders, subverted street signs and much derided figures of authority across the UK. In 2003 his 'Turfwar' show caused the first media stir, with celebrities and the underground crowd alike flocking to see the photos, prints, manipulated paintings and live animal installations in a derelict East London warehouse.

These days Banksy has spread his provocative brand of political vandalism worldwide, commenting on issues that attract the world news headlines, like the abysmal reaction of the Bush government to the New Orleans floods or the political injustice of the concrete walls of Bethlehem. His pieces carry an anti-capitalist and anti-establishment message depicted by the vulnerable and disadvantaged, such as zoo animals, children, homeless or the elderly.

www.banksy.co.uk – Interview Goetz Werner

Opposite – Rat and girl on stool.

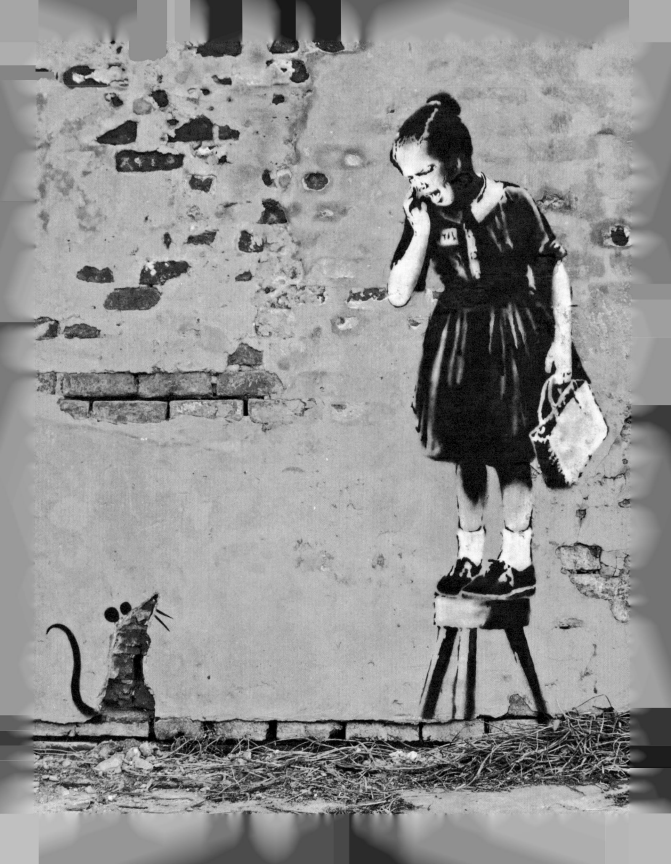

In 2007, Banksy's painting of *The Rude Lord* giving the finger to the viewer fetched a record £322,900 at Sotheby's, London. His celebrity fans include fellow artist Damien Hirst, Brad Pitt and Angelina Jolie, who reportedly spent more than £200,000 at his 'Barely Legal' exhibition in Los Angeles in 2006. The biggest profit was made by an unknown individual who had bought a Banksy piece stencilled on a London newspaper stand for £1,000, and sold it with a reserve price of £230,000. Others have chiselled Banksy pieces off walls to sell them on eBay. His emotional and provocative work has gained such popularity that anything related to Banksy sells, be it the self-published books *Existencilism*, *Banging Your Head Against A Brick Wall* and *Cut It Out* or the limited-edition prints or his original artworks that were first sold by Pictures On Walls,

an art collective Banksy set up with photographer Steve Lazarides.

The caption Banksy installed next to the painting he smuggled into the art temple that is Tate Britain in London reads: 'This new acquisition is a beautiful example of the neo post-idiotic style. Little is known about Banksy, whose work is inspired by cannabis resin and daytime television.'

The weakness of graffiti is its greatest strength. The fact that it's vulnerable to council workers erasing it and kids drawing over it means there is some kind of poetry about it. I often think proper art is a bit unhealthy; 'real' artists convince themselves they are leaving some kind of lasting legacy,

but after the world has burnt to a crisp you won't be able to tell the difference between the dust of one of my paintings and the dust of a Picasso.

I like to make pictures that are obvious, but they are never as obvious as I think. When I first started doing the *Chequebook Vandalism* stuff it was amazing to see what people thought it meant. For me it was all about the billboards, the fact that Donna Karan or Ralph Lauren are no different from graffiti writers putting their names up everywhere. You still sprain your ankle on a broken pavement in front of such a billboard, because the money doesn't go back to the street itself. In the *Goodfellas* movie they say, 'murderers come with smiles' – well, so do vandals; real vandals come with smiles and suits and a great new winter line at knock-down prices.

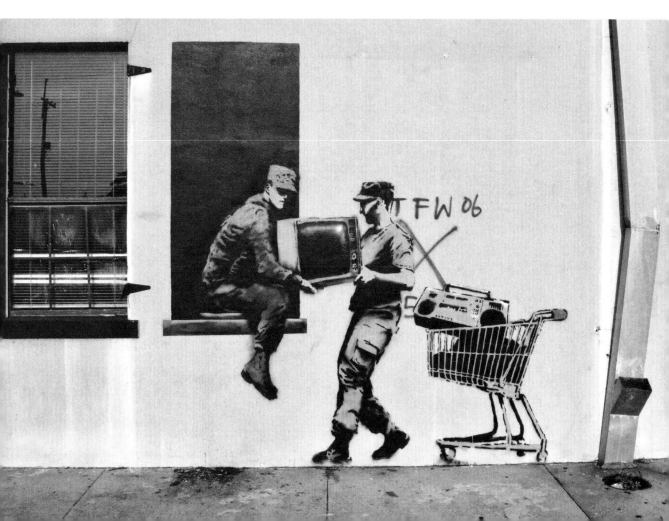

I did find there are ways to use the commercials to your advantage. I have painted pieces in the middle of the day in overalls, and when people asked what I was doing I'd say I was working for the billboard company, and there wouldn't be a problem. If you were to stand there and say: 'I am doing this because I personally feel I have a right to affect my urban environment and this image has as much right to be here as that perfume commercial', they'd probably call the cops or a psychiatrist.

London has become a complete nightmare. I think there's no other city in the world with more security cameras; it's getting harder not to get nicked. I don't have a big fear of arrest, but you don't want to get to a point where every time you step out and make a mark it means instant jail. American jail is more serious than British jail because

Opposite – Banksy stencil of soldiers looting in New Orleans after the flood disaster.
This page (clockwise from top right) – Guantánamo Bay prisoner in Disneyland, live elephant installation at 'Barely Legal' show in Los Angeles and a dividing wall in Bethlehem.

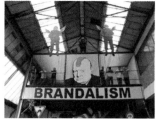

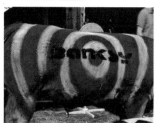
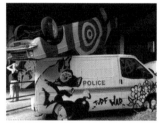
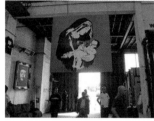

This page – Banksy's 'Turfwar' exhibition in an East London warehouse.
Opposite (clockwise from left) – defaced Banksy work in East London, cat in Liverpool and rats on a London Underground poster and in an East London street.

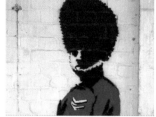

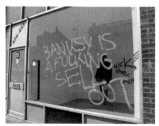

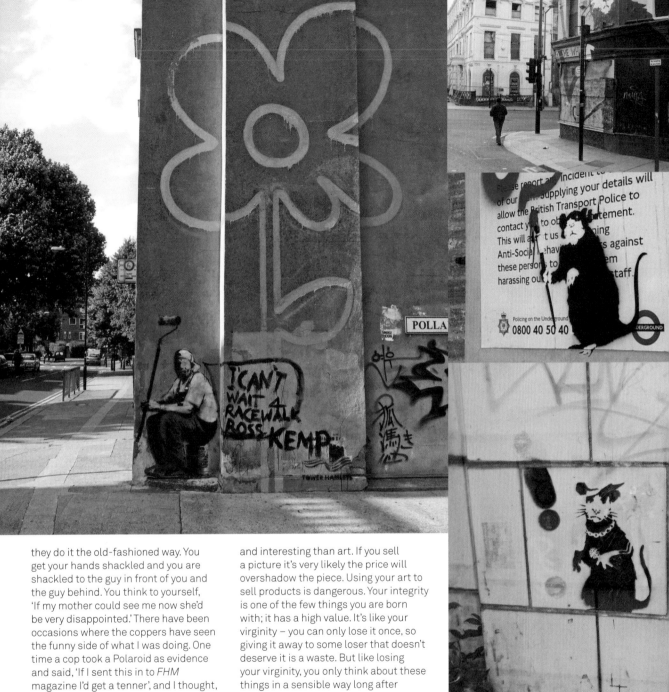

they do it the old-fashioned way. You get your hands shackled and you are shackled to the guy in front of you and the guy behind. You think to yourself, 'If my mother could see me now she'd be very disappointed.' There have been occasions where the coppers have seen the funny side of what I was doing. One time a cop took a Polaroid as evidence and said, 'If I sent this in to *FHM* magazine I'd get a tenner', and I thought, 'You are more of a media whore than I am.'

The commercial side of being an artist is something I struggle with. Mainly because money is so much more sexy and interesting than art. If you sell a picture it's very likely the price will overshadow the piece. Using your art to sell products is dangerous. Your integrity is one of the few things you are born with; it has a high value. It's like your virginity – you can only lose it once, so giving it away to some loser that doesn't deserve it is a waste. But like losing your virginity, you only think about these things in a sensible way long after the event.

Invader

The Parisian artist 'Space Invader' or 'Invader' has developed a series of iconic pixel images, adapted from archaic computer game characters, for his mosaic tile installations in major cities around the world. The omnipresent Space Invader tile installations are a powerful symbol of the digital revolution of the Computer Age. The artist's primary goal is to complete a world invasion of his virus-like creatures, catalogued by so-called 'Invasion Maps', detailing every art installation location in cities such as London, New York or Tokyo.

In Paris alone Invader has installed more than 400 Space Invaders. The maps help followers of the digital invasion to track where new attacks have appeared and support the urban invasion by seeking new locations and buying on-line mosaic kits for self-installation.

Invader is a rather mysterious figure and always appears masked in public; few people know his identity. He is a true urban virus infecting public spaces and not seeking lucrative brand or merchandising deals. Recent works include wall-mounted images constructed out of Rubik's cubes, which the artist calls his 'Rubik Cubist' period. Invader's installations are increasingly presented in galleries and art institutions, such as BALTIC Centre for Contemporary Art, Gateshead, where he created a large-scale Space Invader visible from all over the city.

www.space-invaders.com – Interview Eva Sonaike

Opposite – Invader self-portrait.

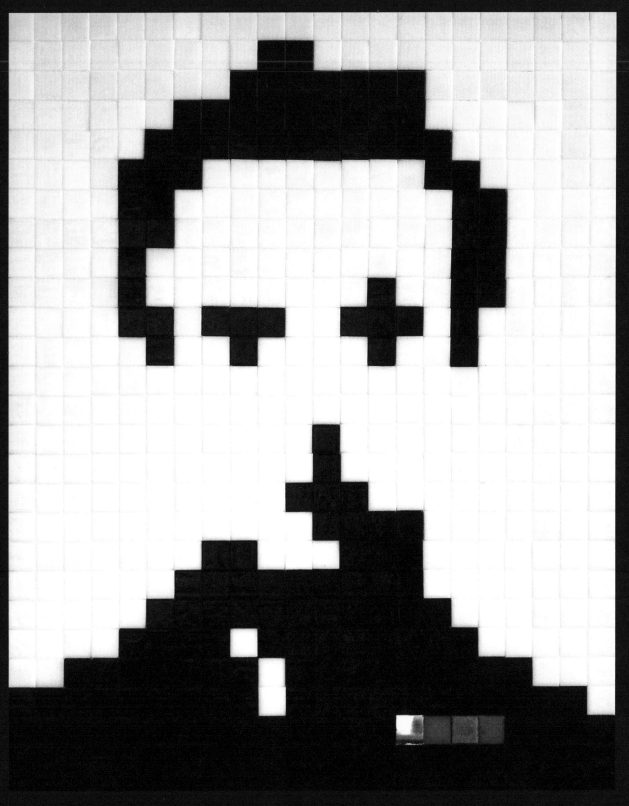

At the beginning I chose Space Invader as a pseudonym because I was invading space with some Space Invader creatures. Then I realized it was a confusing choice, when people for example were writing about me. So I kept the Space Invader name for the project and its creatures, but use Invader as my artist name.

I ride my scooter every day; it is the best way to move in a city. You don't waste time in the traffic and it is the best way to locate new spots. It takes me anything from five minutes to a whole night to put up my mosaics, depending what piece and what spot it is. I get good and bad reactions when I put up pieces, but I generally try not to attract any attention. The most important thing for me about working in the street is the result. Putting a nice piece in the right

spot is a very strong experience because you use the city as a gallery and your art becomes a part of the city and the life around you. Compared to that, museums are like cemeteries.

I am personally not so at ease with the term 'street artist'. But at the same time I guess that people need to put a label on everything. I would say that in the artist family you have the street artists like you have the pop artists or the land art artists' family, and so on. I always felt I was a kind of virus in regard to the art world. I have one foot inside and one foot outside. I have not really felt any change from the institutional art world, but I have felt some from the collectors who are much more interested in my work than a few years ago.

It is a big problem for me when people take my artwork from the streets

because most of my pieces are small and many people try to rip them off the walls. This is ridiculous because most of the time they just get some broken tiles despite the fact they could get the same tiles in any tile shop.

It was natural for me to create the Invasion Maps because I always use a map when I invade a new city. As I wanted to show the importance of the maps in my work process, I started to create and publish my own city maps. The last one I did was Invasion of Kathmandu and it was map number 18. The invasions of Kathmandu in Nepal and Varanasi in India were a great experience for me because it was like a *terra incognita* to explore, without any street art before my coming.

I think I will continue to explore new things in the future. I have tried to stay

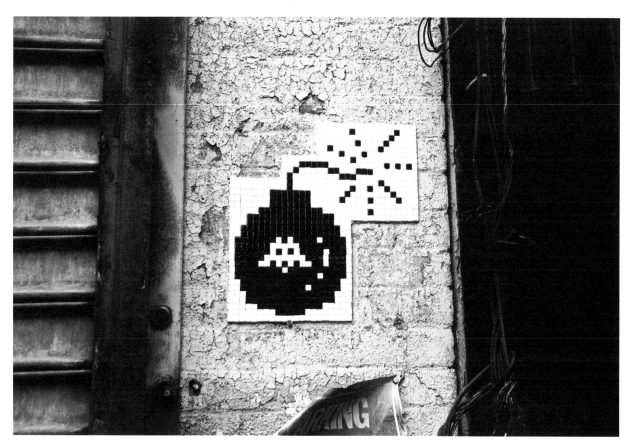

Opposite – *Invader virus street mosaic.*
This page *– Space Invaders around the world: (clockwise from top) New York, Côte d'Azur, Varanasi, Bilbao and Los Angeles.*

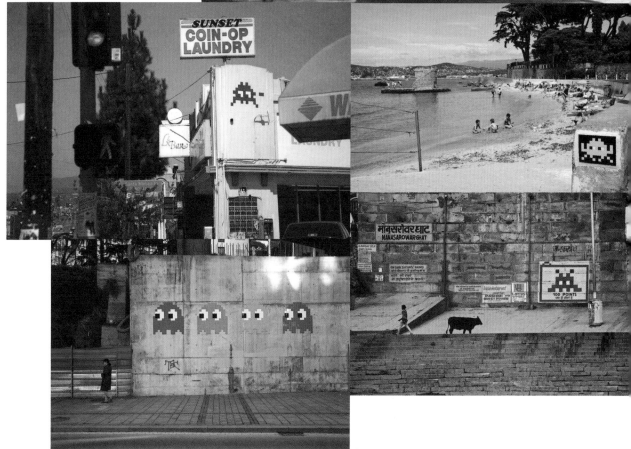

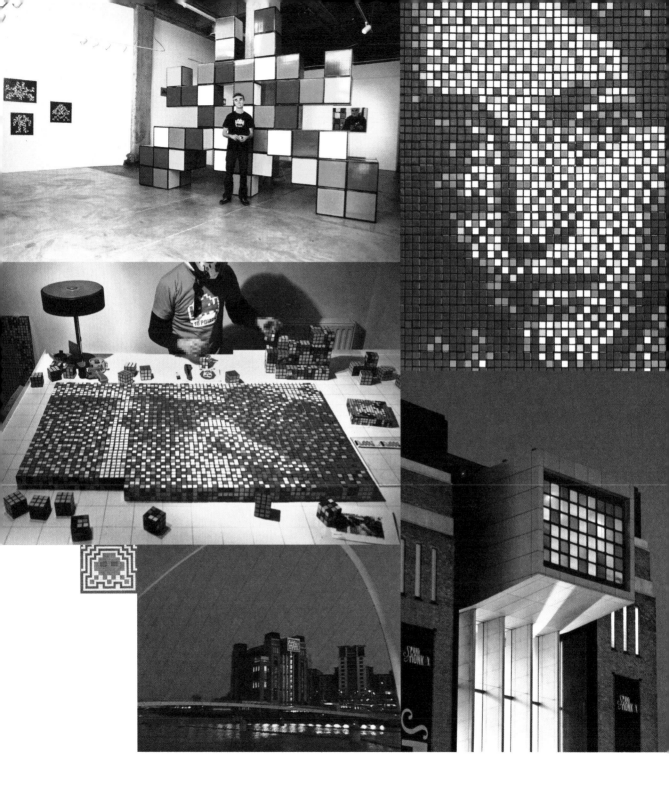

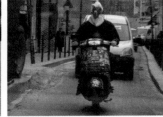
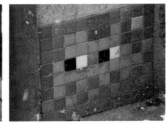

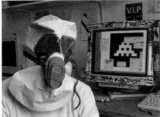

Opposite (clockwise from top left) – Invader at Rubik's cube exhibition, Rubik's cube portrait, Rubik's cube installation at the BALTIC, Gateshead, Space Invader and Invader assembling Rubik's cubes.
This page – Invader with his maps and scouting round Paris for his next invasion.

focused on mosaic tiles since the end of the 1990s because I realized that nobody else did it before me. It was something I could explore more deeply. At the same time it was really exciting to discover new subjects and media with the *Bad Men* series made from Rubik's cubes. It was an important evolution for me, even though it was also based on a pixel aesthetic. Like Space Invaders, the Rubik's cube is a 1980s game made from coloured squares. It's a fascinating object, as it's both extremely simple and extremely complex. There are more than 43 billion possible permutations for a Rubik's cube. I use the Rubik's cube like an artist uses paint. I like the idea that it

wasn't intended to be used in this way. I remember at my first solo show I sold exactly zero pieces. I am now more comfortable because my pieces finally sell in galleries, but the only difference this makes is that it has become easier for me to buy my materials like tiles, cubes and glue. What commercial jobs would I do and what jobs wouldn't I do? It is a balance between living off one's art and not compromising. I generally do not collaborate with brands because I think that it is a different job. Money is not my priority. I used to live like Van Gogh for many years of my life.

K Interact

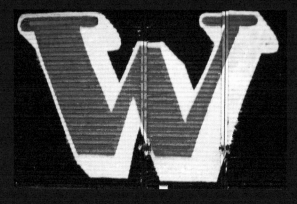

The stretched gunslingers, street fighters and urban survivors of French-born street artist WK Interact have been an integral part of Manhattan's cityscape since the late 1990s. WK was initiated into drawing at a young age by his father, an artist and interior designer. In school he preferred sketching dancers in movement rather than joining in. When he was twenty-one, he left the 600-year-old quaint village he grew up in to find a more suitable space for his street art interest in the Big Apple.

WK Interact's obsession with capturing the speed and flight of the human body led him to develop a technique in which he recreates movement by photocopying photographs and drawings of people, projecting them onto bent surfaces, and copying these projections onto canvas, paper or city walls in the middle of the night. For his layered artworks, WK uses a mixture of his trademark monochrome stencils, paint and bombed skateboards, doorbells and other street objects stuck on the canvas. He also created a series of still frames depicting rapid movement of the human body, similar to early Eadweard Muybridge motion photography.

www.wkinteract.com – Interview Denise Langenegger

Opposite – A selection of WK Interact's work around New York.

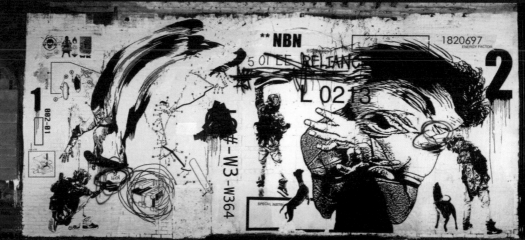

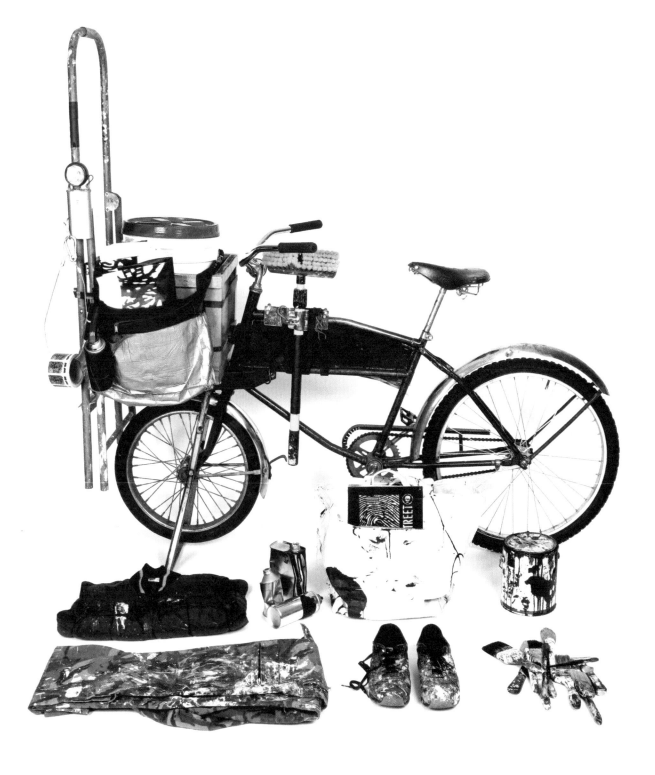

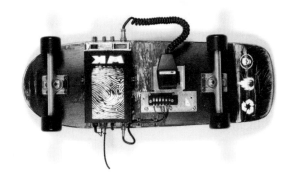

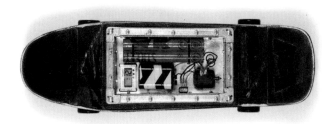

The pushing, stumbling and running figures create a slightly eerie sense in the streets of New York and other cities around the world where they appear. The threat of WK Interact's skaters, boxers, BMXers and martial artists is accentuated by the passing people who merge with the life-sized street paintings. WK Interact's dynamic and energetic imagery is a reflection of the psyche of New York and its rushing citizens.

The master of street motion has applied his love for dynamism and energy into various exhibitions at Parco gallery in Tokyo, Studio 101 and JFK Airport in New York, Galerie Lafayette and Agnès B's Galerie du Jour in Paris, Elms Lesters Painting Rooms in London and BLK/MRKT in Los Angeles. Collaborations include the exhibition 'Obey Giant vs. WK Interact', *Impact* with Nike's Kobe Bryant and a 154-metre (505 foot) billboard of the boxer Prince Naseem in London.

I came to New York to mix my images with the street and with the architecture here. If you look at the gunslinger image it has only two colours, black and white; it's like a big sign you can find on the street. I think this city fits so well; it's so futuristic, so radical. If you look at the paintings without their surroundings – without the phone, without the piece of metal, without the little sticker – it would not be the same thing. That is why I am doing a lot of stuff on the street. The sun changing, the people passing, the cars stopping; it's all so emotional. It's just nice to create images and move people just like that. That's what I like. I basically find the street and the spot and afterwards I usually sit and think about what will fit the place. I like really big human-sized paintings, because that's when the art mixes with the people. It's so important to interact with the location and people passing by; that's what I'm looking for. But initially I work on a very

This spread – Part of WK Interact's 'guerilla gear' range of tools and uniforms for urban bombing and pasting.

small image and when I come back, I project the image. You have to calculate exactly how big you can project and be sure you're going to have the right size. WK itself doesn't really mean anything, but I usually use my finger to stamp each wall that I paint. My real name is too long.

The street has some kind of freedom, it instils an anarchic way of expressing oneself. But because you have so many different street corners in any city, the most interesting idea is not just to do something obvious and commercial, but to create a different story in each of your pieces. But it can be difficult to spread these stories, because there are so many different things that can interfere with the process of painting: most of the time the sidewalk is not very good; the sun in summer is very hot; in winter it is very cold, it's almost freezing and the

paint doesn't dry. It's very difficult. You also have a lot of people coming to ask questions, so sometimes you can lose a day just talking with people, not really painting anything.

The other problem is that a lot of commercial companies grab each little piece, and it's almost impossible to find places. Like one wall I did, it was such a great spot and now Levi's has taken it and pay US$6,000 a month just for this spot. I won't pay US$6,000 a month because for all the painting I am doing on the street, nobody pays me and I don't pay them to get my own image on the wall. US$6,000 a month is a lot of money for a little spot like this. It's New York! I was lucky to be here at a certain time, and now New York is growing up very, very quickly.

I believe the early days were the best time because I was making something without getting paid and it was exciting. My payment was the interaction with people; how they interpreted my work and what their reactions were. Now it starts to be a kind of work and I am constantly doing different projects. It's difficult to say no to the work you get offered because people will not understand. But then again, I'm happy with the way everything has worked out. Coming to New York was a big challenge for me. New York gave me the chance to come up with my own image and my own style and that's why people started to recognize me. I'm from France and the French people would never give me half of what I got here. It would have taken me 35 years, maybe more, to get the same recognition.

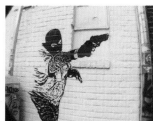

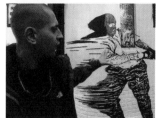
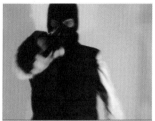

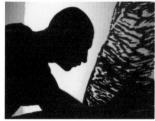
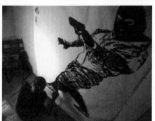
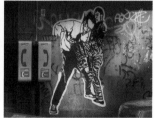
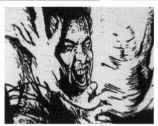

Opposite –Rising Bycke.
This page – WK Interact in
New York on the street and
in his studio preparing the
gunslinger stencil.

s gêmeos

Inspired by the first wave of hip hop culture that swept Brazil in the mid-1980s, São Paulo twin brothers Otavio and Gustavo Pandolfo, aka os gêmeos, got into painting graffiti through breakdancing, classic films like *Beat Street* and *Wild Style* and the influential *Subway Art* book. In 1993, they met US street art pioneer Barry McGee, aka Twist, who lived in São Paulo for several months. This chance meeting was their first significant artistic exchange outside their São Paulo environment. McGee's legacy encouraged artists to take inspiration from their own experiences. He encouraged the twin brothers to develop a more lyrical folk style, which very consciously included traditional Brazilian and South American culture.

Gustavo and Otavio work simultaneously as a team, outlining and colouring each other's dream-like depictions of flying animals, clowns, street kids, musicians or family portraits with mermaids. Os gêmeos pieces often feature distinctive spindly-limbed, yellow-skinned characters who populate the decaying walls of São Paulo's buildings. The twins' artistic output ranges from expansive tags and murals to more abstract paintings, sculptures and art installations.

Interview Goetz Werner

Opposite – Twins Otavio and Gustavo Pandolfo at work in São Paulo .

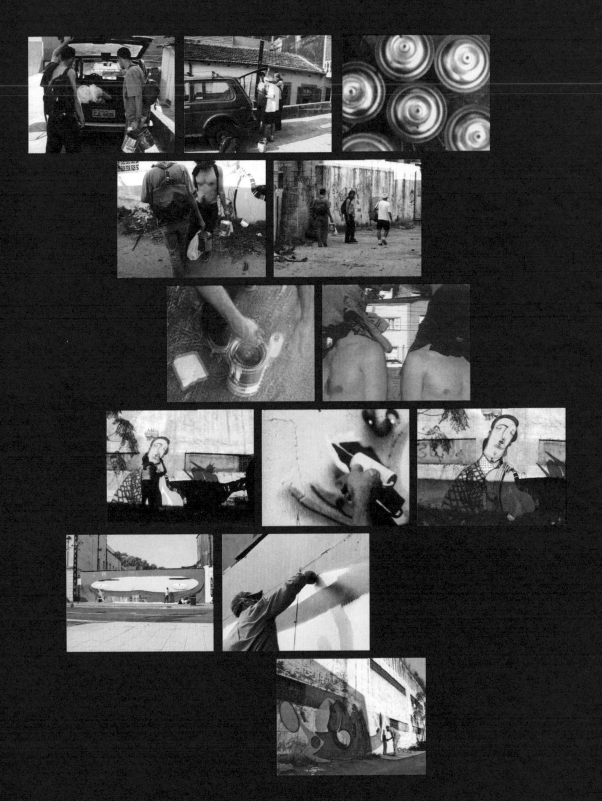

Os gêmeos have gained international recognition for their pioneering street work in São Paulo. Like many of their contemporaries, they have made the transition to mainstream art. Their first exhibition outside Brazil was at The Luggage Store in San Francisco, followed by solo shows in Los Angeles, Tokyo, Australia and Argentina. They have also created mural collaborations in Havana and São Paulo as part of the CubaBrasil project. In Europe, os gêmeos took part in group shows in art institutions including BALTIC Gateshead and Tate Modern.

However, Otavio and Gustavo are still among the most prolific and inventive painters on the streets of São Paulo. Where they used to run into trouble with the police, they have now been invited to paint large-scale mural commissions and even legally bomb one of São Paulo's commuter trains.

We believe in what we dream. A lot of what we paint is based on what we dream. A lot of it is also based on what we see in the streets. There is also the stuff that we know from Brazilian folklore. A lot of the time our paintings really do not have a story. It's what we were dreaming of, what we just decided to paint. It's never really too premeditated. We normally just show up and start painting. It's like a photograph of a scene that's already in our heads. It's something that we think or dream about; it's a way of materializing our dream. São Paulo is a very big city and it's an anarchic place. There are all kinds of different artistic manifestations. There is Pixação, which is mostly just tags and large letter typography on the walls, which is a typical thing from São Paulo; it's very individual and specific to the city. When we started painting we were really influenced by old school and hip hop styles and now the new generation that is starting to paint is influenced by what we are doing. We have always tried to develop and not necessarily to follow what has been done elsewhere. It is all about how we feel, and we feel that São Paulo graffiti will increasingly evolve into something different with its own styles, with its own characteristics, with its own personality.

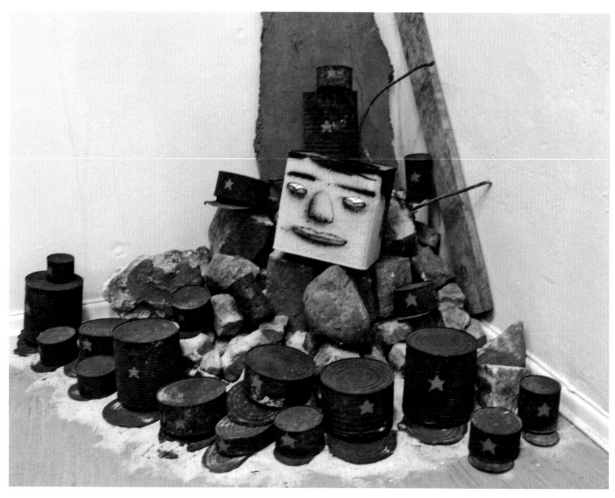

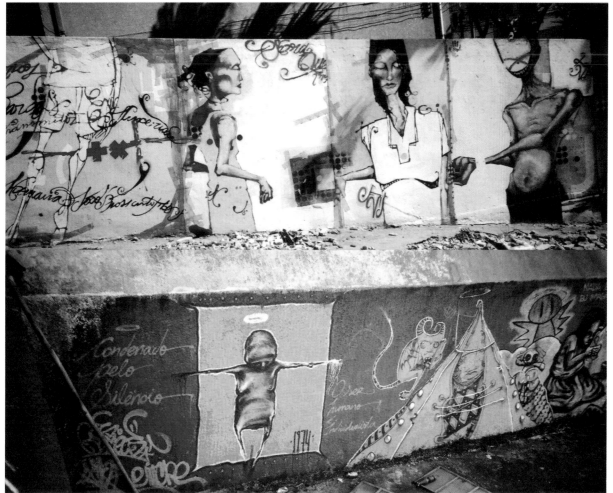

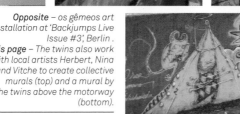

Opposite – os gêmeos art installation at 'Backjumps Live Issue #3', Berlin .
This page – The twins also work with local artists Herbert, Nina and Vitche to create collective murals (top) and a mural by the twins above the motorway (bottom).

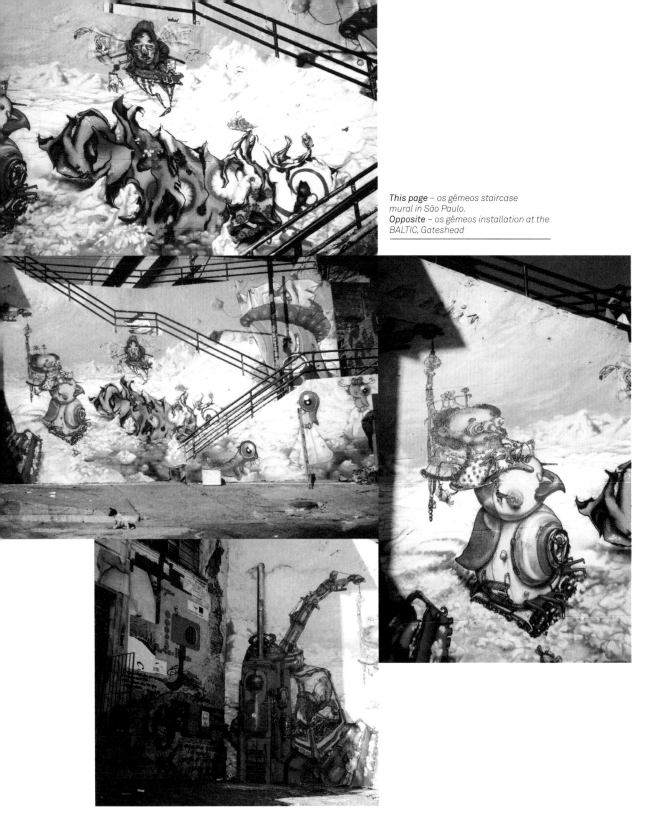

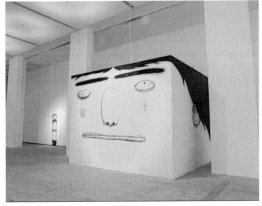

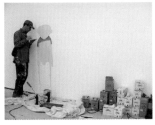
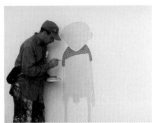

The price of paint is really high in São Paulo. Kids cannot afford to buy spray cans; they are just not affordable. That's why they prefer to use latex paint and rollers. It's a lot cheaper. The police situation is also really unpredictable in São Paulo; you never know what's going to happen. The cops might show up and not do anything, at the same time they might show up and throw you in jail for a long time. Anything can happen when you're painting, which adds to the style in a sense – as an unpredictable element comes into it. But at the end of the day we don't care about the police. We just want to paint and that's what we will keep doing.

We like working with other people. Fellow São Paulo artists Nina, Vitche and Herbert are very close friends. They have similar tastes, they like the same things, they even believe the same things. But there are a lot of other artists we have worked with, people like Loomit from Germany. We admire every kind of graffiti. We like artists who are not stuck in what everyone else is doing, we like people who have their own particular style. There are a lot of artists in South America, a lot of good artists in Chile. It's always interesting to have access to their styles and get to know their work. It ends up influencing us and our work probably ends up influencing others too. The most important thing about this exchange is to feel what the other artist is doing. A lot of the time we don't speak the respective languages but we communicate through our artwork.

Of course things have changed. We make a living from our art now. But whenever someone is paying for us to paint, we no longer consider it graffiti – we consider it decorative art. Only when we paint on the street is it 100 per cent about yourself. You are not painting something that someone else wants; it's really your own expression. Everything around you influences your work. Painting on the street is the real art; whatever commercial art you're doing is just work.

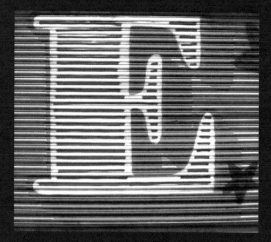

ine

London-born Eine, aka Ben Flynn, started out as a hip hop-inspired street vandal because he felt he was not good enough for breakdancing. In the mid-1980s, he joined small-sized train tagging graffiti crews and got arrested several times. Before establishing himself as a street artist, the former Lloyds insurance claims administrator worked as an in-house screen printer for Pictures On Walls (POW), a collective that sells prints of street artists on-line and via specially organized event galleries in unusual locations, such as the Santa's Ghetto show which was held in a derelict store in the middle of London's busy Oxford Street.

After quitting his job at the Banksy-associated POW, Eine now concentrates on his career as an artist. And as such he is inspired by Keith Haring and Andy Warhol, as well as by Young British Artists like the Chapman Brothers and by the DIY attitude of art-superstar Damien Hirst. Eine has had solo shows in the US, Japan, London, Newcastle, Copenhagen and the über-cool Colette store in Paris. His street typography has received recognition in graphic design publications like *Eye Magazine*, *Design Week* and *Creative Review*.

www.einesigns.co.uk – Interview Sebastian Peiter

Opposite – Eine working on the 'A' of his shutter alphabet in East London.

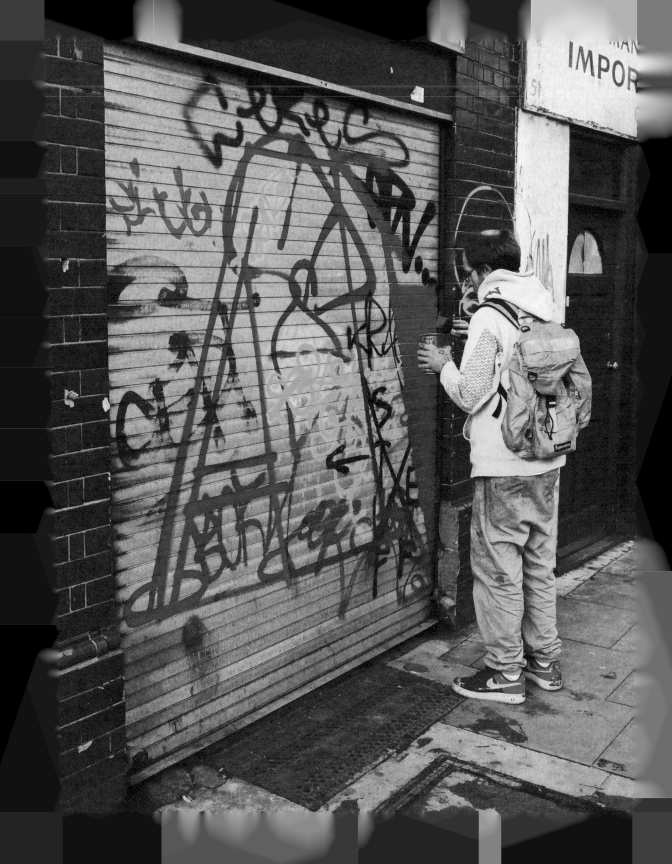

Ben still feels equally at home in the studio or on the streets, where he leaves huge one-word pieces like SCARY or VANDALISM, toying with the public's deep-seated fear of graffiti tags. His trademark gigantic single antique letters painted on countless East London shop shutters have become an integral part of the urban landscape. The letter pieces are so much loved by the locals that they even survived a council survey which asked if they should be removed. Referencing old illuminated manuscripts, Eine's shutter alphabet has been used for record covers, television titles and as this book's chapter headings. For his 'Care Bear' series Eine developed a technique by which he can prime canvas with concrete and cover it with a range of Care Bear street fighters armed with bottles, knives and nunchakus.

I spent years being your typical graffiti-type person – spray cans, trains, tagging, vandalism; and slowly I got older and older and not so fast on my feet. So I began to move into street art which is just a lot friendlier, isn't quite so antisocial and is more accepted by members of the public. So gradually, I moved from hardcore vandal to street artist.

A friend of mine, Cept, was out with me one Sunday morning and we had two roller shutters that we were going to paint. I felt a bit limited by just continually painting my name over and over and over again in this one shape. It was outside this nightclub called Herbal on Kingsland Road when I thought it would be quite funny, rather than write the name EINE, to paint a gigantic E. So I did a gigantic E a lot quicker than Cept painted his name. There was a shutter next door so I did another E. I just thought, I'll do an I on another, an N and then the other E – writing my name across four shutters. I took the photographs and thought, why just write my name? It's going to be a lot more interesting to do the entire alphabet.

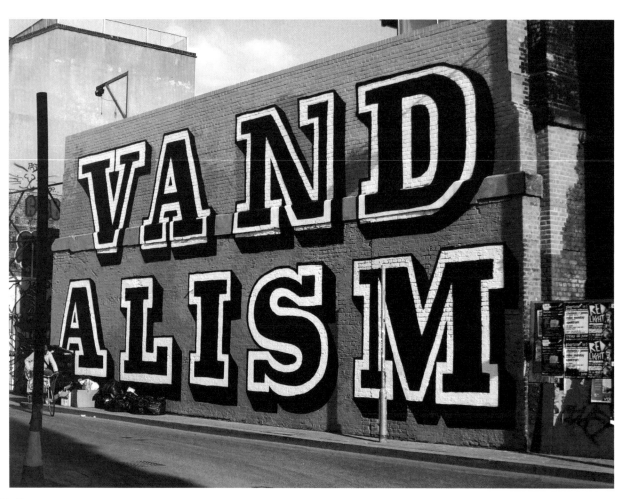

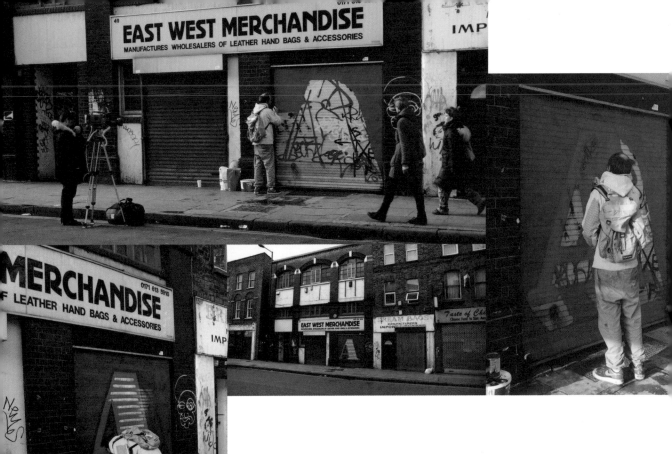

Opposite – Eine mural in Shoreditch, East London.
This page – Eine completing work on the 'A' of his
shutter alphabet in East London (top) and the
complete shutter alphabet (bottom).

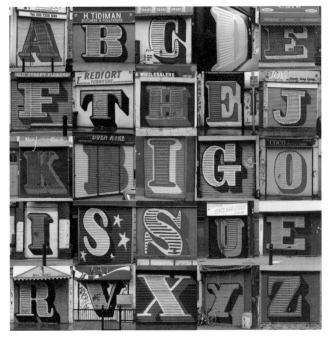

It's going to create more interest
because it's going to have less
association with graffiti. As I was
painting the shutters, lots of people
wanted to buy or own a part of what I
was doing on the street. So I've done all
the individual letters of the alphabet in
various screen prints and then larger
canvases in different fonts, like this
Circus font.

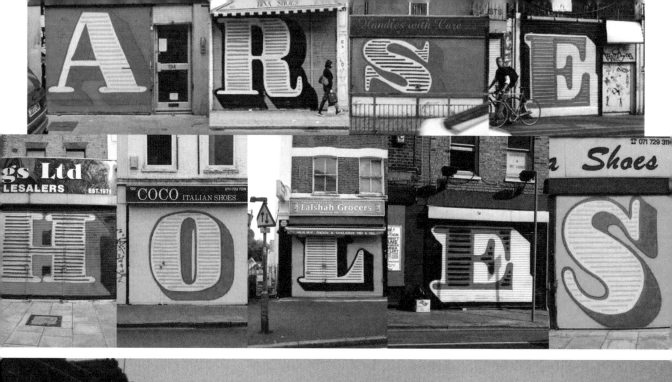

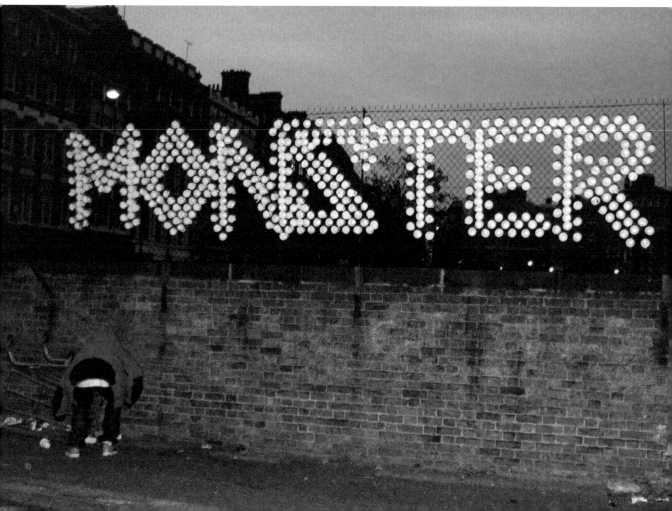

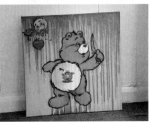

Street art is a new movement and a lot of the people who are involved in it are not tied to art gallery traditions. Because street art / graffiti / vandalism – whatever you like to call it – has been shunned by the traditional art world, these artists have had to find their own ways of showing and selling their work. They are young entrepreneurs. They are quite happy to take over an empty space, get together with a few people and present their work on their own terms. Another way of doing this is on the Internet. Most of these artists have their own galleries on their websites showing what they are doing. All these websites are regularly updated. Somebody goes out and paints something on the street, and the next day it's up on their site. These websites are a way for artists to sell their work, cutting out the galleries, cutting out the agents and dealing directly with the buyer. There is a huge amount of press, a huge amount of interest. At the moment, street art is very cool. It is always in magazines. Advertisers are constantly using it. Big brands want to be associated with this street art movement. It's a way for them to look cool.

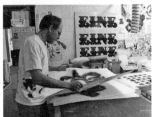

I enjoy painting stuff on the street. I enjoy vandalizing things. To me that's where my art belongs and that's where it should be. Painting canvases, having shows and galleries is completely separate. Street art in a gallery environment is quite sterile. The gallery, the museum world is quite sterile. Galleries and museums document the past. What's happening on the street is now. However, you can't buy that wall that I've just painted 20 minutes ago down on Hackney Road. I do have to live and I do have to survive, so making canvases, making screen prints is a way for me to survive. And it's a way for my art to continue living, because everything that you paint on the street will at some time be cleaned; it's not going to stay there forever.

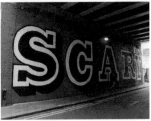
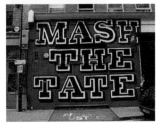

Opposite – Artwork created using Eine's shutter alphabet (top) and Eine installation of cups in a fence.
This page (from top) – Eine working on his 'Care Bear' series, Eine murals next to his 'Kemistry' exhibition in Shoreditch and Eine screen printing at Pictures On Walls (POW).

oki

Noki is an artist, visionary and conceptualist frock maker who creates sustainable one-off fashion, inspired by street art. His early 1990s T-shirt dresses were distressed, punched, tagged, gaffer-taped, inverted and labelled with messed-up brand logos like 'No Coco' from Coca-Cola or 'Hard Cock' for Hard Rock Café. Noki's trademark balaclava masks are used for all of his media interviews and public appearances as a stand against celebrity culture.

When the former art student from Aberdeen settled in London, he worked as an MTV stylist and hung out with fellow fashion designers and party heads Fee Doran and Giles Deacon. His first catwalk show in 2002 was held in a derelict East London music hall with quirky fashion pieces made from 100 per cent recycled materials.

Noki's customized collection pieces are some of the most ripped off items in the fashion industry. He has designed a limited-edition adidas trainer named, in typical Noki fashion, Oink Don't Piss. Each pair was individually designed. Noki has also contributed to the New York catwalk show of Luella Bartley and regularly appears in magazines such as *Vogue* and *i-d*.

www.novamatic.com -- Interview Sebastian Peiter / Photos Dr Noki and Sebastian Peiter

Opposite – Customized Noki fashion piece.

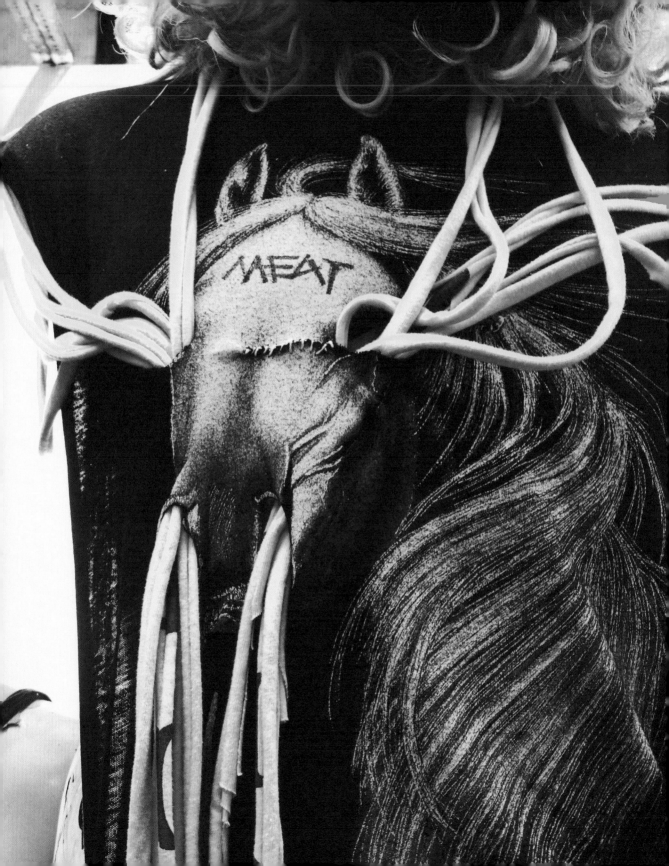

Since his first catwalk show, Noki has turned urban spaces into art installations, plastering the walls with paintings, prints and graffiti – creating a unique stage for fashion and live music performances. His latest venture brings the master of reinvention back to East London, where he has set up a workshop/vintage store/fashion gallery, welcoming visitors to his NHS. The Noki House of Sustainability promises to rejuvenate fashion victims under the supervision of Dr Noki and his staff nurses behind the sales counter.

My first connection to street art would have been living in Old Street, when I moved up to London in 1995.

It was very downbeat, very raw, very desolate like the old spaghetti westerns. Then the Bricklayers Arms opened up and we all started getting drunk in there. The Blue Note was old and dusted, Metalheadz was kicking off. It was street art in the sense of an energy. It was more about the people who were involved in the area. You could sort of feel it. Old Street being quite desolate and quite empty, you could make a mark and it would shine out. I was doing a lot of street art, and just tagging Noki. I don't do pieces at all, don't do throw ups. I only use spray cans for stencilling, which is a direct action.

When I was working at MTV, I was doing a lot of generic styling, doing the big corporate thing and getting the big brands in and sticking them on. So I felt like I was perpetuating the problem, rather than doing anything particularly creative. Good job, great fun, lots of exciting people would come through the doors in Camden. You would have budgets for clothing and you would be in the markets a lot of the time, which really fine-tuned a lot of my ideas. While I was doing that I wanted to break away and do something more interesting, so Noki was originally a magazine called *Nokipod*. But it never really happened; it's a very difficult market to get into. My naivety didn't really help much either. But I just had this name Noki – it was icon turned around. I was basically trying to do a subversive magazine, break down the icon's ego.

My work can look quite arrogant and aggressive, but behind it is lots of love

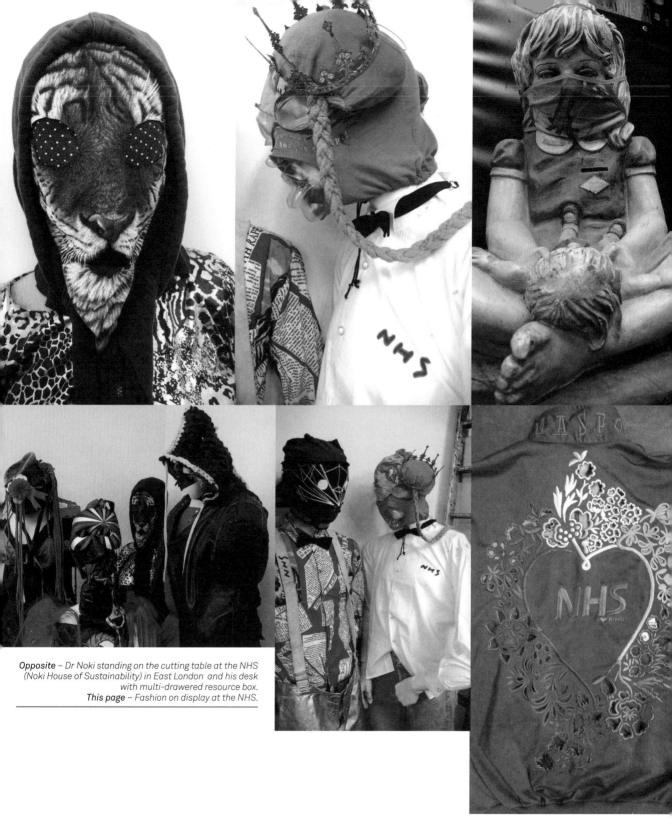

Opposite – Dr Noki standing on the cutting table at the NHS (Noki House of Sustainability) in East London and his desk with multi-drawered resource box.
This page – Fashion on display at the NHS.

Noki demonstrating his fashion range at the NHS.

and attention to detail. I like to work from a sustainable angle. I'm more into the direct action DIY: reclaiming stains on T-shirts by putting stencils over the top – so you reclaim it and nobody knows the stain was there, and then the print goes down. My favourite materials would be branded T-shirts, cracked broken print, blacked, washed-out fabric and gaffer tape, because it's like an old hip hop reference to gaffer taping somebody up, chucking them in the back. A violent thing, but then what I try to do in Noki is a passive-aggressive stance. It's anarchy, but it's a different kind of anarchy, in the sense that my anger is cutting, that when I cut the T-shirt, or I hole punch the T-shirt, when I slash it, that's my breaking McDonald's windows or

standing with a protest pole aggravating police and aggravating the corporates. In my head I always treat everything I do as one big installation. Even somebody buying a piece of Noki from the shop and walking down the street in it, they are basically doing a silent protest. Because it basically was something mass market, now it's not; it's jammed, it is subverted, it plays on the whole culture jamming ethos – a term that was coined in Canada by Kalle Lasn from *Adbusters* and the Negativland band.

I like to have my anonymity. Every time I do the mask I'm giving out my art. I'm making you react how I want you to react – pull away, be scared, be very scared. Because when it comes down

to fashion, if you start looking into the branding of things, if you start to read into culture jamming and *Adbusters*, there's a lot of very scary subliminal stuff happening that demonstrates that we as a generation don't have a clue what is going on.

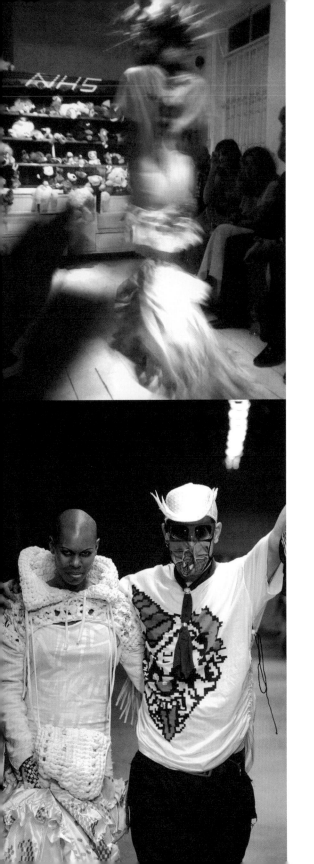

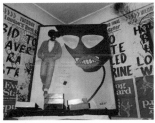

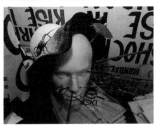

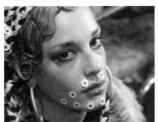

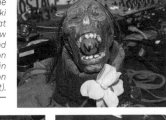

Catwalk show at the NHS (top left), Noki and singer Skin at catwalk show (bottom left) and Noki art installation and catwalk event in Brighton (right).

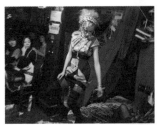

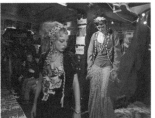

ndré

Swedish-born Parisian street artist André Saraiva's stick-figure tags became a common sight in Paris until a probation order stopped André from putting up any more of his 'Mr A' characters.

Before his arrest in Paris, André adapted the old graffiti tradition of name tagging into the popular Love Graffiti project – a tagging-by-order scheme where members of the public commission a name piece of a loved one to be done in their chosen neighbourhood. Love Graffiti is an early example of André's talent for successfully turning his artwork into a business. The clever street artist charged a fee of US$2500 per name, sometimes even clearing permission with the local authorities.

André's breakthrough as a business operator came when the Parisian modern art temple Palais de Tokyo asked him to open an alternative art store in the museum's foyer. The resulting BlackBlock store has become a visitor attraction in itself, offering the latest work of André's many street artist friends plus André's art collaborations with toymakers, trainer brands, fashion and even chocolate manufacturers.

www.monsieura.com – Interview Sebastian Peiter

Opposite – André's stick-man murals in Paris .

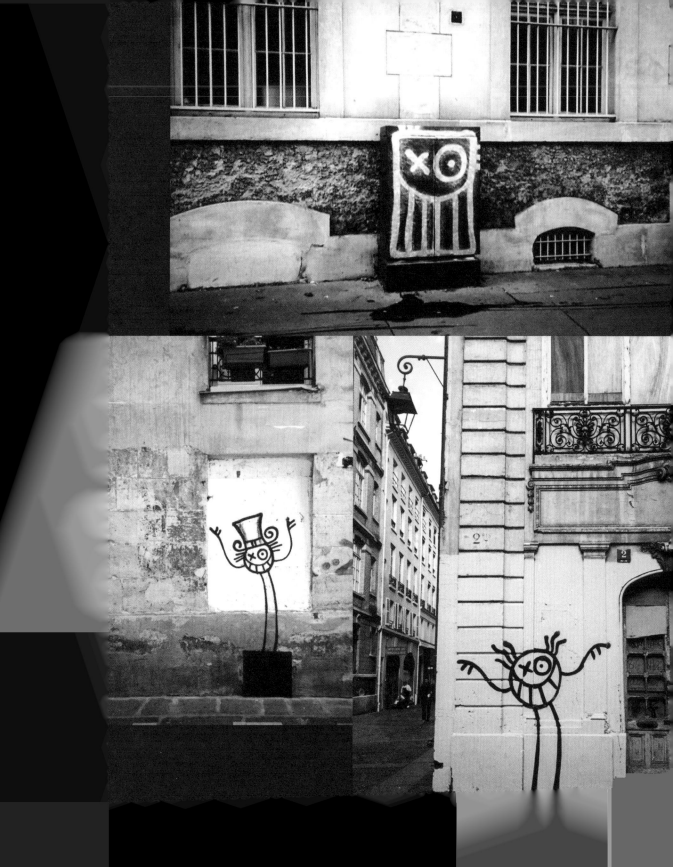

Over the years, André has expanded his business with various joint ownership projects involving people who are his friends rather than just investment partners. He opened one of Paris's most exclusive clubs, Le Baron, with Lionel Bensemoun. Together they were soon asked to stage Le Baron nights at the top art fairs around the world, including Art Basel Miami Beach, Frieze (London), The Armory Show (New York) and the Venice Biennale. André's other club, Le Paris Paris, has become a platform for new dance labels Ed Banger and Institubes. When André was looking for a place for his friends to stay, he came up with the Hotel Amour in Montmartre, with its individually designed rooms. New York's hipster bar restaurant, Beatrice Inn, is a collaboration with A.R.E Weapons member Paul Sevigny. Le Baron Tokyo is André's latest joint venture with product designer Marc Newson.

André is a true cultural entrepreneur who still feels very close to his graffiti roots. Wherever he goes on his frequent travels around the world, he puts on his work outfit and leaves his signature stick-man behind.

Some artists are inspired by an aesthetic, a technique or the work of other artists. I like a lot of people in the graffiti world. Those I know, they are my friends; they are like good neighbours to me. I have always been different in the graffiti world, in the way that I chose to do characters instead of writing my name, which I did in the late 1980s, early 1990s, when nobody else was doing it. So yes, in that I was an innovator. I am still experimenting with things in the street; it's my favourite form of expression.

The 'street art' label has always bothered me, but it is part of my life. I have always done graffiti on the streets. I consider it art, as much as the work of renowned contemporary artists. People in the art world are still not very familiar with it.

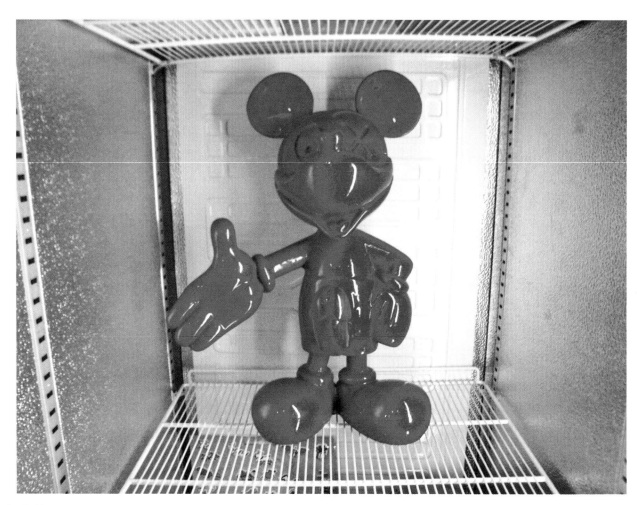

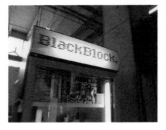

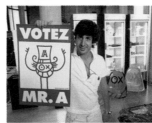
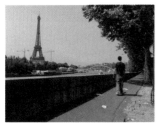

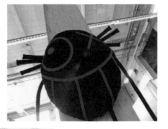

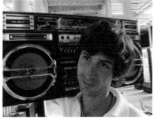
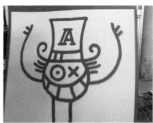

Opposite – *André toy on display at his BlackBlock shop in Paris.*
This page – *Mr A tag in Berlin (top) and André at BlackBlock.*

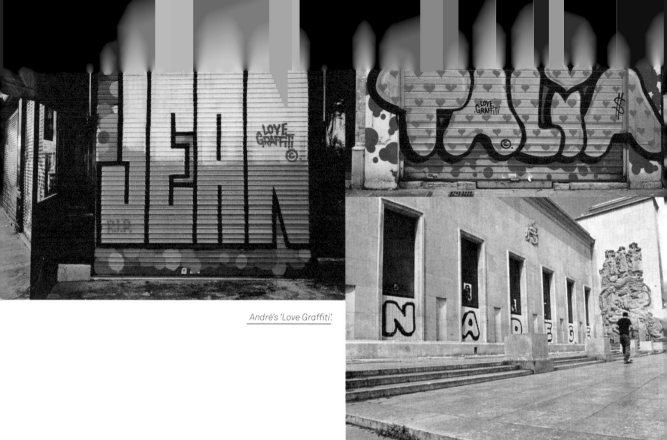

André's 'Love Graffiti'.

Graffiti has evolved pretty well in the world. People start to care about it a little more, maybe less so in France – except for our cops. It is a generational thing too. People who grew up with graffiti culture are starting to be in charge now. Graffiti is part of their universe. Graffiti directly or indirectly influences people. There is a sort of presence to the work that only a very few big street ad campaigns can match. Graffiti has always been the poor child of hip hop. That has allowed it to keep its purity, because graffiti is essentially based on the streets. It is illegal. All the artists who struggled to paint every night for years, for an ephemeral glory, deserve to make some money out of T-shirts or exhibitions. I am proud of the fact that people I used to admire earn a living by doing ad campaigns now. Why shouldn't

graffiti artists do commercial deals? I don't mind that they are finally making money now, as long as they ask a lot for it, because graffiti artists have done so much for free in the past.

BlackBlock is an experimental store in an art museum, where I showcase my and my friends' work in refrigerators, just as you would sell beer. We reinvest all the money in new art commissions. I have always been a fan of toys. I collected them, especially Star Wars figures. It is a sort of subculture fascination. Our culture can be expressed by toys, comics, tattoos or custom cars. It is part of my universe. I put them all in the same box. Today's vinyl figures from Michael Lau or Kubrick are fascinating. They are not designed by big companies but have an aesthetic chosen by artists. We have

always dreamed about this; now it exists. We grew up with a real culture of action figures, merchandising from movies or cartoons. Lego, Playmobil, Star Wars figures – I should talk to my shrink about this.

I have many different projects. I organize events and other things. But I have never stopped painting on the streets because it makes me feel alive. Cops keep arresting me. Each time it pisses me off a little more, but it also makes me want to do it again. I try to have fun and have no boundaries. It keeps me going in an emotional way and introduces my work to new places.

A new generation of graffiti artists is emerging. They draw, stick up posters, paint logos and I have no problem with

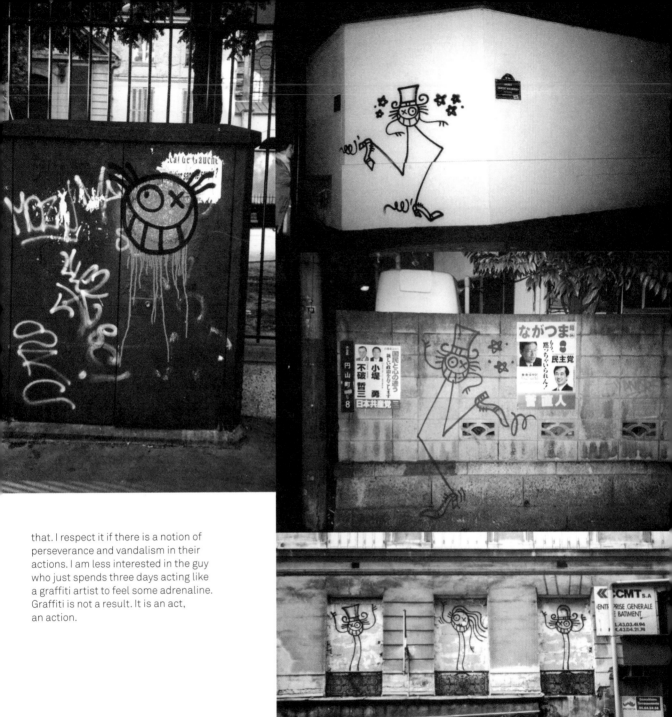

that. I respect it if there is a notion of perseverance and vandalism in their actions. I am less interested in the guy who just spends three days acting like a graffiti artist to feel some adrenaline. Graffiti is not a result. It is an act, an action.

Stick-man murals around the world.

evs

The anonymous Parisian artist Zevs is a street artist in the real sense of the word. All of Zevs' output is closely related to his continuous street action.

Zevs started as a graffiti-inspired tagger in the mid-1990s before he moved on to drawing white shadow outlines of street signs, scooters, benches and other still-life objects lit by the street lights of Paris. He then became known through a series of 'Visual Attacks' on the countless advertising boards that litter the urban landscape all over the world. One of the most spectacular attacks was filmed for the *URBANATION* television series in 2000 in the middle of the day in the centre of Paris. A masked Zevs with a ladder attacked five gigantic fashion billboards by executing the pretty fashion models with a dash of red spray-paint placed right between their eyes. Other victims include bus shelter ads and the 'Visual Kidnapping' of a model, which was cut out from a gigantic Lavazza advertising canvas in Berlin's Alexanderplatz. Zevs' three-year kidnapping campaign resulted in the coffee maker finally handing over a ransom/donation of €500,000 to the Palais de Tokyo gallery in Paris.

Interview Markus Storrer

Opposite – Chanel, from Zevs' exhibition 'Liquidated Logos', Lazarides Gallery, London.

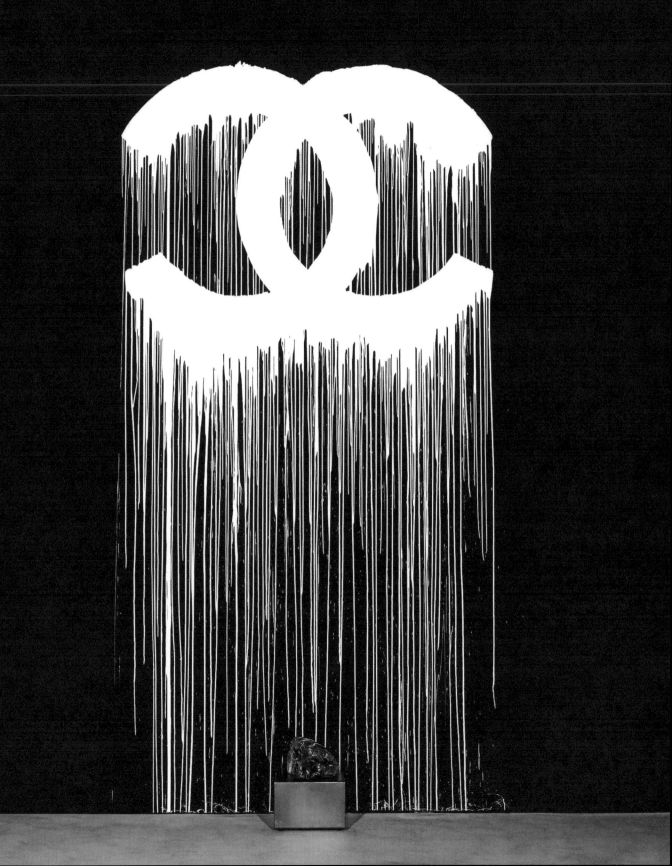

The liquidation of brand logos has become another important weapon in Zevs' arsenal against the visual dominance of consumer culture. Large shop and billboard signs of McDonald's, Nike, Gucci and Coca-Cola have been attacked with bleeding paint. Invisible graffiti using UV-filtered lights and 'Clean Up' graffiti are Zevs' latest attempts to wrest city spaces from the corporate world of advertising. Using a high-pressure jet, Zevs 'cleans' his messages into dirty city walls. In a clever twist on brand obsession and counterfeit culture, Zevs reworked the Louis Vuitton logo on a Zevs handbag showing the original Leonardo Da Vinci LDV monogram, on which the fashion brand had based their design.

Zevs shows canvas, photographs and print works of his street actions in established art galleries and urban art showcases Backjumps, LazInc and Santa's Ghetto. He also does the occasional performance masked and in his trademark yellow and black workman outfit at exhibition openings or club nights at Le Paris Paris owned by fellow Parisian street artist André.

At the beginning I was making graffiti and tags on the streets. I was often changing my name. One day I was doing one by the railway tracks with a friend. I was on Line A of the RER and I nearly got run over by a train. Each train has a name, like graffiti artists do, written on the front with small lights. This particular one was called Zeus. That's how my artist name came about.

I have no political message. I only work by impulse. It's a work that does not last. I used to work against the city. But after a bit of reflection, there are a lot of triggers when you work on the streets, the way people see your work. So I try to work with the city. For example, for a long time I have walked the streets by night and observed how the city is made. At six o'clock in the morning all the street lights in Paris shut down. This moment is beautiful. All the shadows suddenly disappear. That made me want to underline those things that we don't notice anymore. It's a way to leave a print of the night without going against the city.

Painting to me is like eating and sleeping; it's a necessity. It's better to paint by night when people are asleep, nobody bothers you. But you can work during the day disguised like a chameleon, dressed like a town hall worker – someone who blends in. You create a workspace with traffic cones and people don't pay attention. I wear the helmet and a fluorescent jacket. If it's a shop shutter, night-time is better.

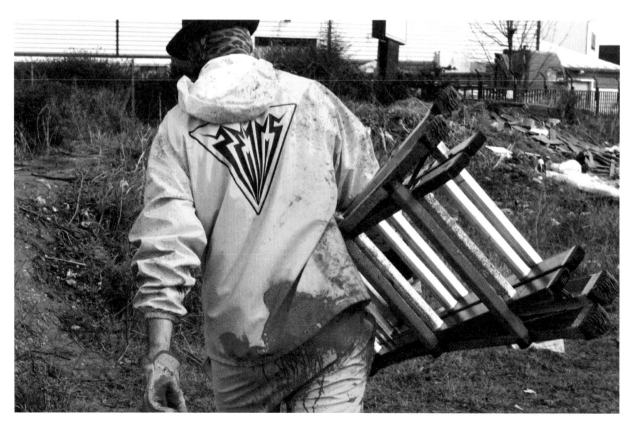

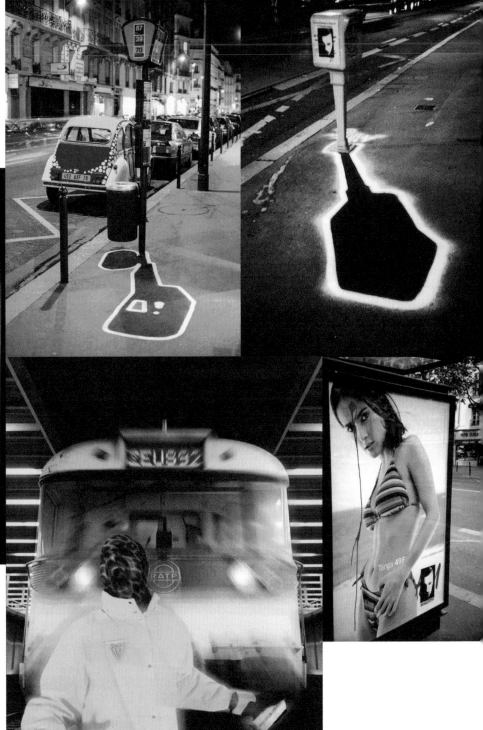

Opposite – *Zevs in his work outfit.* **This page** *(clockwise from top) – Zevs' shadow pieces in Paris, 'Visual Attack' on a billboard, Zevs in front of the RER train that inspired his name, billboard 'Visual Attack'.*

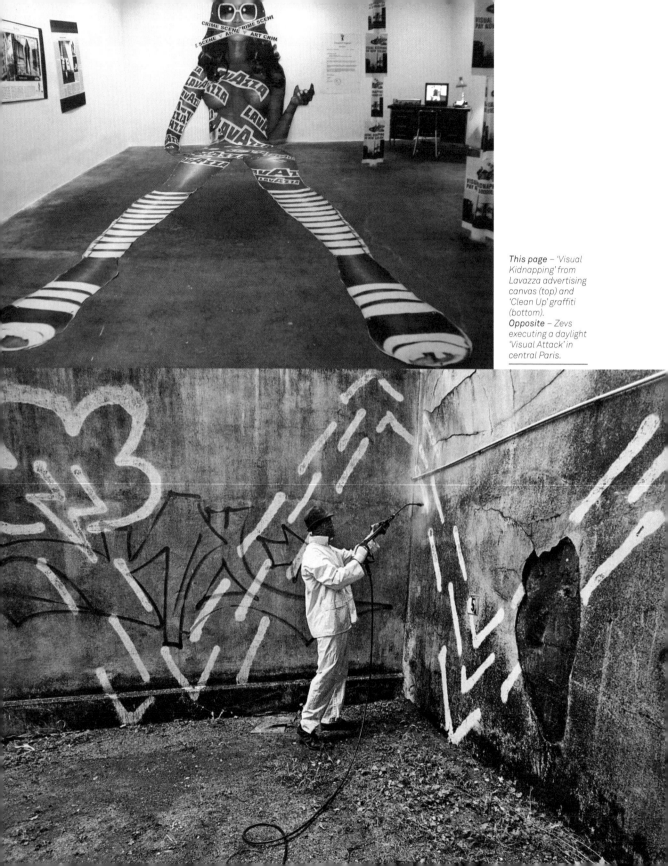

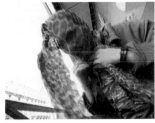

If it's something bigger, daytime is better. You work as if you are part of the city. Some people do notice something odd, but most of them don't – even the police don't. Once I made them believe for two hours that I was doing the shadows so the elderly don't bump into lamp posts. I was saying, 'Of course, I am working for the town hall so an old person seeing the shadows will see there is an object that you must dodge', or something like that. But at the end I was still taken to the police station. The public don't get as angry with my work as they do with tags. By night I meet amazing people and we have a chat. Interesting things happen, some amazing meetings. People don't prevent me from doing what I do.

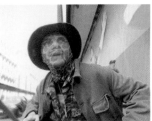

I travel by scooter; it's more practical to find good spots, that's how I move in the city. The good spots are everywhere, sometimes hidden, sometimes so obvious you don't spot them the first time. I always look forward to knowing what is going to be the next ad campaign. One day I managed to get the key to the advertising display boxes. JC Decaux is the company which puts them up. I had a chat with one of the guys and he gave me the key in exchange for a few notes. Suddenly it was like having the key to heaven. I could get access to the ads that are untouchable because of the glass in front of them. I could make an intervention on those icons; turn them into victims – fashion victims. I always retake the picture of an ad afterwards, so there is photographic evidence of my work as well. I always take the picture with the reflection of the glass. I like making paintings under adrenaline, I really love it.

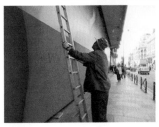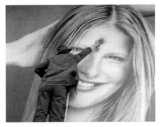

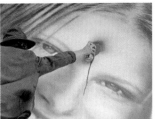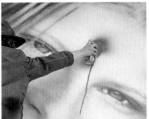

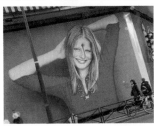

iss Van

French-born Barcelona resident Miss Van started wall painting in the streets of Toulouse in the early 1990s. Her endless variations of wide-eyed voluptuous beauties in bright acrylic colours and old-fashioned pin-up poses have become a common sight in graffiti hotspots all over the world. While studying art in Toulouse, Miss Van met Mademoiselle Kat; the artists share a similar vision and both are credited with introducing female styles into the male-dominated street art scene. Miss Van calls her seductive female characters 'Les poupées de Miss Van'. These nameless baby dolls are a cross between reality and fantasy, and were developed to express melancholy, sadness and other moods of their originator. Miss Van has created limited fashion editions for Fornarina and exhibits in New York, Berlin, BALTIC Gateshead in the UK and Magda Danysz gallery in Paris.

www.missvan.com

Opposite – Untitled, 2007.

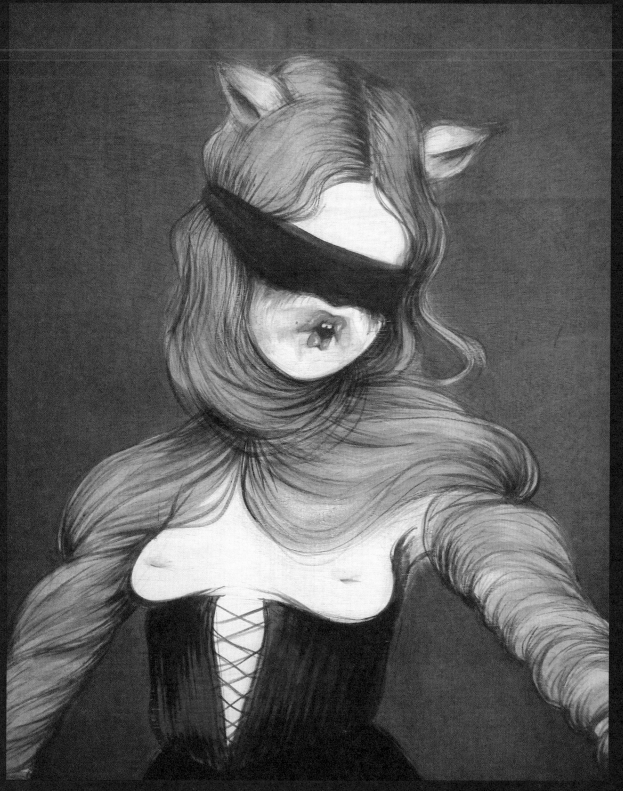

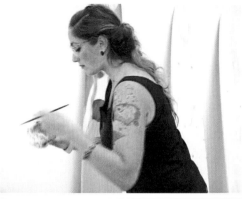

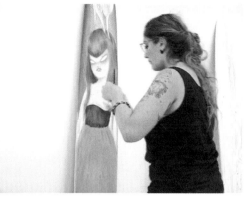

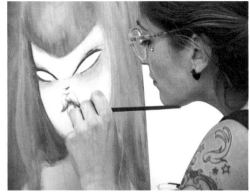

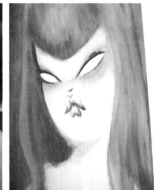

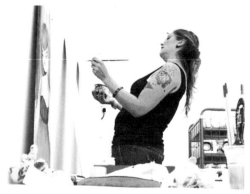

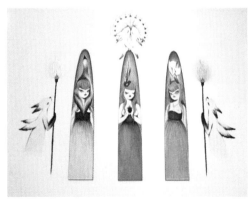

This page – *Miss Van at work at the BALTIC, Gateshead exhibition.* **Opposite** (clockwise from top) – *Miss Van work in Berlin Mitte, drawing in Galerie Magda 'bla bla' exhibition, at work at the Manchester Doodlebug Day, street work in Barcelona.*

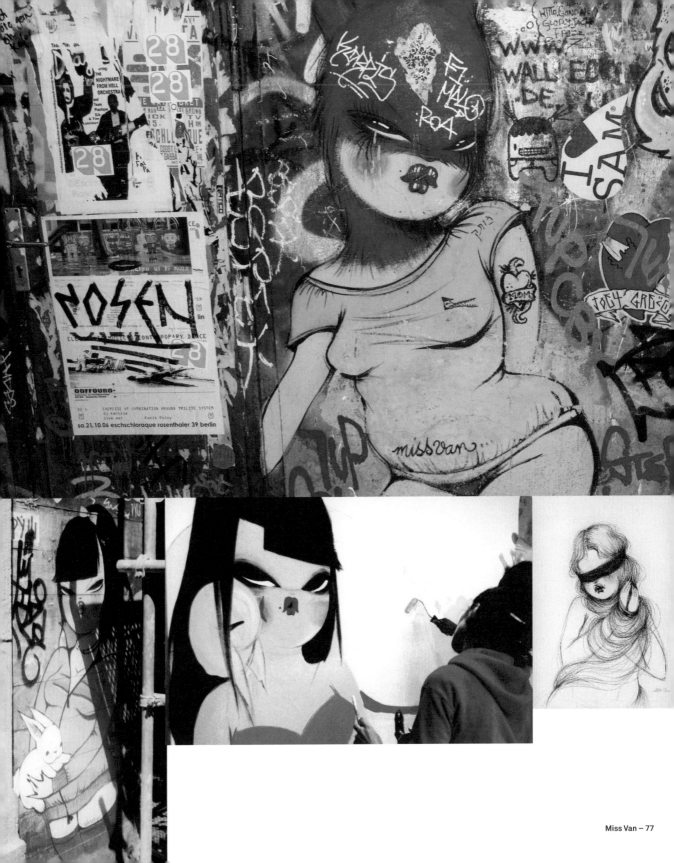

arnstormers

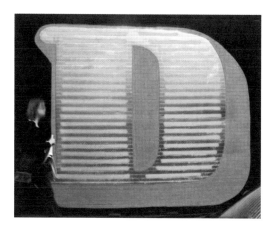

avid
Ellis

Working in groups has a long tradition from New York's early graffiti days. David Ellis, aka Skwerm, is the founder of the New York-based Barnstormers crew. This North Carolina native has formed one of the most respected collectives in the street art movement. The Barnstormers are a diverse and innovative crew with 20-plus members from Korea, Japan, Ukraine as well as all over the United States, branching out to include street artists, photographers, musicians and film-makers.

Over several years David has toured the North Carolina countryside with the Barnstormers to paint as many farm barns as they could, dismantling, for example, a massive 1930s tobacco barn, reassembling it and painting more than 20 murals on its side for gallery exhibitions and recorded live paintings. David Ellis developed a technique of recording the Barnstormers' collaborative work that he calls Motion Paintings. Using time-lapse photography he records the creative process, and then compiles it into a film set to a jazz soundtrack.

www.b-stormers.com – Interview Christian Fussenegger

Opposite – Two installations by David Ellis.

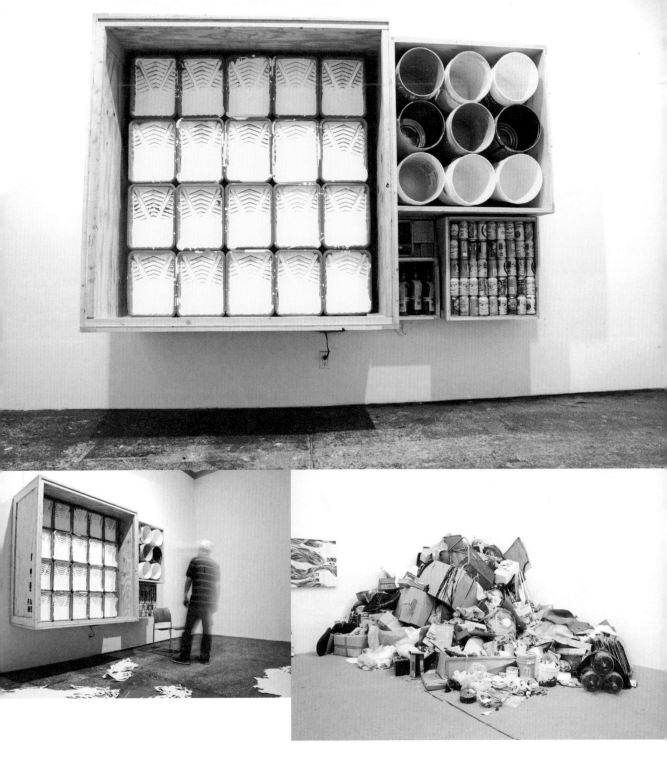

With his personal work and solo shows, David Ellis refuses to be pigeon-holed into any particular style – although nature, in particular trees, is always a strong theme in his work. Whether it's his art direction for a Modest Mouse pop promo, the collaboration with live-action design company Motion Theory for the NIKE Presto ads or the Barnstormers Motion Paintings, David Ellis always crosses the boundaries of street, art and commercial work.

For me it all began a long time ago. When I was growing up in North Carolina I felt a little remote, with not much more than tractors and barns. I was influenced by the whole graffiti scene – things I was seeing coming out of New York. So I played my part. I came up with my tag 'Skwerm' and did a few barns.

I eventually moved to New York and decided it would be nice to go back and just blow it up, maybe do a hundred barns, so it's kind of full circle. That's how the Barnstormers crew started. Though I think it's not really a crew, but probably more of a project that involves a lot of artists from a lot of different corners of the earth, who merge together in this small rural part of the South to make paintings on barns.

It's great to go down now because much of the North Carolina community supports us. They come out and give us ladders, places to stay and bring food. We have always been surrounded by this vibe. We have actually involved a couple of local kids who were around every day, kind of getting in the way. We gave them their own barn and talked to them about what they wanted to paint. They were really into Pokémon, so Blust 1 outlined some Pokémon characters and that

took them a couple of weeks. I am interested in the response on that level from the community. Hopefully it will inspire people to do barns on their own, or whatever.

Thinking about the possibility of doing art in my life – that was probably the big distraction when I was growing up. In my childhood there was no role model demonstrating how to be an artist. There was not much to do. But this whole art thing got me motivated and I got out. When I moved to New York, everything was getting cleaned up and not being from there, I didn't have anybody I could run with at that time. So I focused more on developing classical techniques. As the years have gone by, I'm moving more and more back to trying to do that. I'm doing a wall now in my neighbourhood. It's getting me thinking a lot more about the streets.

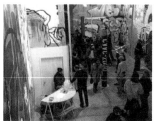

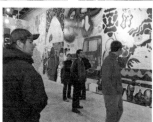
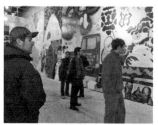

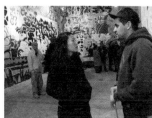
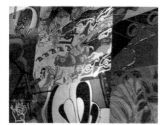

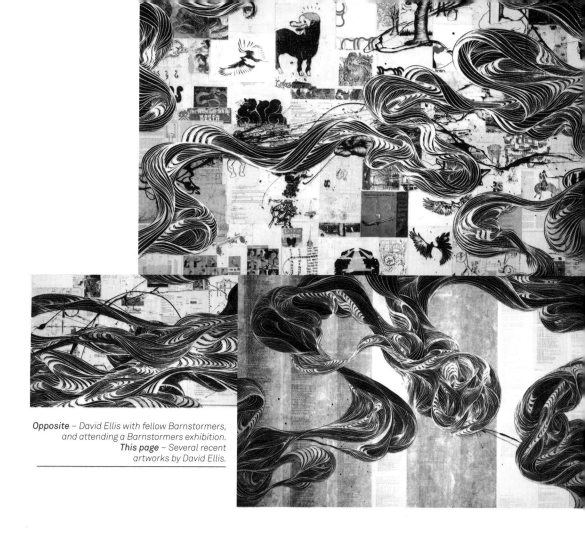

Opposite – *David Ellis with fellow Barnstormers, and attending a Barnstormers exhibition.* **This page** – *Several recent artworks by David Ellis.*

I would compare working together on Motion Paintings to improvisational jazz music. Everything in the room can set off an idea. It's usually better to come with less of a planned thing and let the vibes of the place become a part of what you're doing. It's important to put the ego down a little bit or it can be a fighting match and it can turn into a bad experience. You want to do something in the area that you're working in that will enhance and inspire the others to climb up a notch and hopefully leave a place where you can connect. It's a difficult thing. Out of all the times that we've done them, half have fallen short. But the paintings that have succeeded are just mind-boggling – the contrast, the scale of it, everything.

I think the most successful collaborations have been slowed down

a bit because we work on a fairly large scale. But even with the scale we work in, we end up covering it pretty quickly. It's a matter of having trust in the other people who are going to paint with you. It's a matter of slowing down and really respecting and looking at what's there and trying to plug into it. You also feel like you've got just one shot. You are not behind closed doors and you can't erase it if it doesn't come out right. What's on the end of your mind and the end of your brush has kind of got to stay there. For me there are always a lot of ideas going round in my head. It's just a matter of which ones are going to gel together at that time and the vibe of what the other painters are doing that might spark it. In the future I'd like to push it more towards doing a battle, like having another group of painters who feel comfortable

painting live, like a sound clash. I think that would probably bring things to another level.

But I'd say more than anything, I'm seeing work of all kinds happening on walls – not only things that are specifically considered graffiti, but things that happen on the street. There is just an energy about the street. It's such a force. The same block is going to look slightly different every week, so I just keep my eyes open. I'm interested in the kids that are climbing up on rooftops and hanging out of windows and doing death-defying climbing acts to get their pieces in the middle of a building or something. That's what really inspires me, I'd say, these days – more than what's happening inside the art institutions.

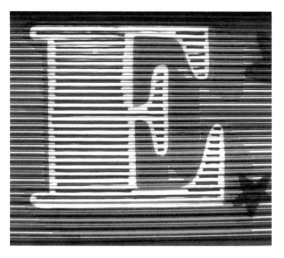

spo

Born and raised in the Overbrook neighborhood of Philadelphia, Steve Powers, aka Espo, moved to New York in 1995. He published the influential *On the Go* magazine, but it was through painting storefront gates of vandalized and closed-down shops in TriBeCa, Bedford-Stuyvesant and the South Bronx that he really made his mark on the Big Apple.

Working in daylight and wearing street clothes, he would cover entire gates with white or silver paint and then his name. When passers-by asked what he was doing, he'd explain he was cleaning up the gates as part of Exterior Surface Painting Outreach. The initials ESPO soon became his artist name. Despite his guerilla tactics, Steve was arrested and charged for vandalism in 1999.

Fed up with the New York attitude towards street art, he took part in an artistic pilgrimage to the rural town of Cameron, North Carolina, where he became one of the founding members of the Barnstormers collective in 1999. Today, Espo is one of the most successful and critically acclaimed street artists, and has successfully stepped into the gallery world. His art has been shown around the globe at the 49th Venice Biennale, Deitch Projects in New York, Cincinnati Contemporary Arts Center, Liverpool Biennial and Parco Gallery in Tokyo.

www.firstandfifteenth.net – Interview Christian Fussenegger

Opposite – Espo and Espo tags.

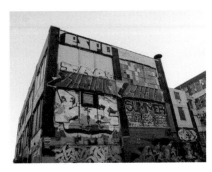 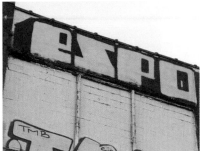

It was great to get out of New York City with the Barnstormers and take a trip south to North Carolina, where people generally appreciated what we did. There was no stigma, no feeling of violation; people really celebrated that we came down and gave our time and best efforts to make something happen in their community. This is such a dramatic contrast to the aggravation and the alienation that most artists get in New York City. Here, artists are treated like panhandlers, booksellers or aggressive pamphleteers. To be given love and the means to do what we had to do, wonderful surfaces to paint and friendly support from the people in North Carolina – it was incredible. It's the way it should be! And then I came home and had the police at my door aggravating me, and it's just been hell ever since.

But, thanks to the kind people in North Carolina, at least I got a glimpse of what it could and should be. You can have as much space as you want in New York City as long as you're fast and smooth about it. But to be given something so gratefully and so completely, that's unheard of here. New York is all about the fact that everything costs money. The space you're standing on, somebody wants to charge you, the air you breathe, if they can find a vending machine for it they will. To have the opportunity to really do something that's real and incredible, costs nothing

and just to get the support you need to make it happen, that's the best – that's just life and the way it should be.

In New York you develop a mentality that it's you versus everybody else, because you have all these people coming at you from all sides trying to do you harm. The people down in North Carolina broke all that down, and wanted to create work that really celebrated them. So all of us as artists tried to develop works that would really speak to the community. I had some crazy sketches of what I wanted to do that reflected a real New York mind state. But once I got into position and felt what was going on, I had to throw that stuff out and start over and really try and give the people things that reflected them, things that they could draw from and feel good about.

I don't really know the historical origins of the word 'Barnstormers'. Sometimes it was selling medicines, or maybe you were in a small baseball team. The name got attached in a lot of different ways to people travelling to get word out across the country very fast in a pre-television and pre-jet age. 'Barnstorming' was going from one location to another in a really fast way to get your message across.

We have carried the 'Barnstorming' thing to a variety of areas. It doesn't have to be paint on barns, but it really is about the fact that we are individuals and we

go into the community, draw from the community, hold a mirror up and reflect back what we see. I think 'Barnstormers' is as permanent as names tend to be. I think it's about the fact that a moment was crystallized into a movement. As the months went on and the experience soaked in, we were able to sit back, and that's when you really start to value the relationships you made and see the importance of what happened. It took on a whole new dimension. We may not have been a community from the start but we became one in the process of the work we created.

With regards to the future, in rural settings, I guess the Great Wall of China is still open. We'll just call it as we see it. We're very spontaneous and I had no idea what we were going to paint until we saw the surfaces to paint on. That's a lot about where we come from as street artists and graffiti writers – you see a surface and you mark the surface. You seize the space and make something, hopefully interesting and unique, happen that reflects who you are and what your personality is about. So there is no real objective. There's just us, and we'll make the objective happen, hopefully.

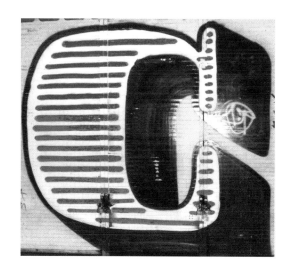

he
Jen

Born in Seoul, South Korea in 1968, Che Jen moved to New York with her family when she was five years old. She had a formal education in art from primary school to college, but initially was opposed to the idea of becoming a 'full-time' artist as her career choice. However, growing up in the late 1970s, Jen's visual instinct was inevitably drawn to graffiti, street proliferators, billboard adverts and other visual media outlets — all influences that remain relevant in her work today. Che Jen's recent work has been rooted in an exploration of natural physics, which links back to urban decay, layers of paint chipping, constant overlapping of adverts and the elements pulling the layers away.

Che Jen has progressively fused traditional Korean and tribal styles with street art influences, creating unique, brightly-coloured images of intrinsic ornamental patterning and ancestral imagery. At The School of Visual Arts in New York, Jen met fellow student and street artist David Ellis, aka Skwerm. Later when their paths crossed again, Jen was one of the first to join David's Barnstormers collective.

www.chejen.com – Interview Goetz Werner

Opposite – *Several of Che Jen's recent works (clockwise from top left):* Abyss, Turn, Untitled, Flight *and* Embers.

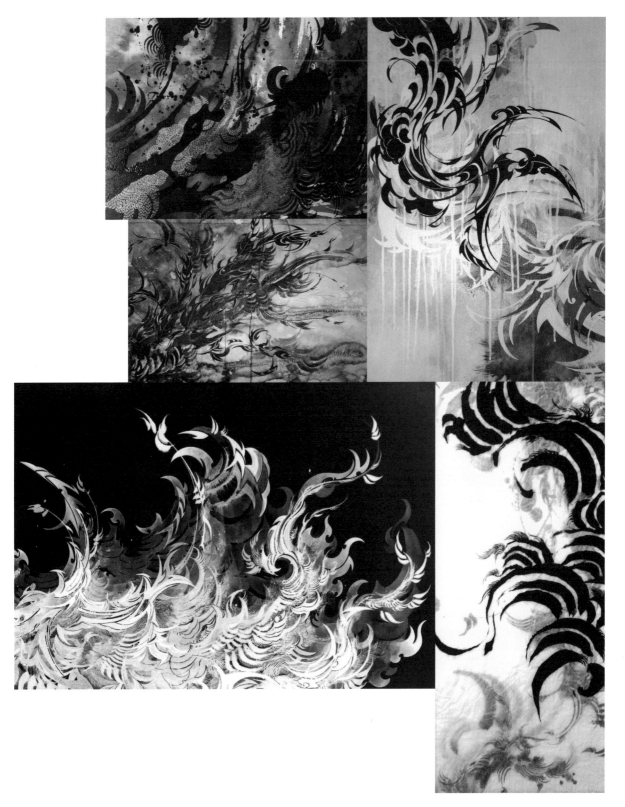

The Barnstormers trips to North Carolina have been a life-changing experience for Jen, not just for the creative exchange with other artists, but also because she met her future-husband Mike Ming at one of the first barn-painting journeys.

Che Jen worked for the Atlantic Avenue Artwalk and collaborated with Doze Green, Bo 130, Yuri Shimojo and Microbo for the 'Troubles Never Come Alone' exhibition. Most recently she has prepared a West Coast show with Kenji Hirata.

I wasn't really painting until about a decade ago. I was too involved or distracted with other things to realize that painting was necessary to my life. I had been pushed into the arts as a kid, so when it was imposed – my reaction then was to oppose it.

Painting is a chemical transformative process for me, whereby thoughts and ideas manifest in lines and embody movement on a physical plane. I have always been drawn to the idea that nothing is static – not our words, nor our thoughts; that they all have and contain energy and power. I hope to reflect this specific energy in my paintings. The tribal and indigenous influences of our ancestors – the Torah, the Koran or the sutras – they are all stories, spoken, handed down and imprinted in our genes. We can reflect on these myths and evolve. What sustains my existence is that I do have a line – we all have a line – of ancestors. Factually, I am a make-up of their stories. I am regurgitating some of the stories, injecting them with modern life while also making up some new ones.

My art is reflecting the tensions, conflicts, struggles and the decay of urbanization – all that comes from growing up in NYC, but it could be the same in any urban nation. You can see, smell the decay; fuse into the tar streets and the concrete; become part of the layers of paint peeling; witness the dripping of acid etchings on subways. Taste the city's sweat. I can say now, in retrospect, how growing up in NYC in the 1970s affected me in speech, culture, style and mentality. My works are not separate from who I am, they reflect it.

The Barnstormers did change a lot of things in my life. The whole experience was pivotal; it kick-started my whole painting day-to-day thing. There were a lot of exchanges with the people involved, inspirational and otherwise – an amazing group of artists. It was chaotic, unplanned, unstructured and within that we grew more independent and solidified our own styles and intent. It was experimental. We created a lot of the installations together. There was a lot of improvisation to it; chaos played well then. The effect of the work as a whole was unique – the multiplicity of ideas, styles and approaches. The differences somehow fusing into 'one'

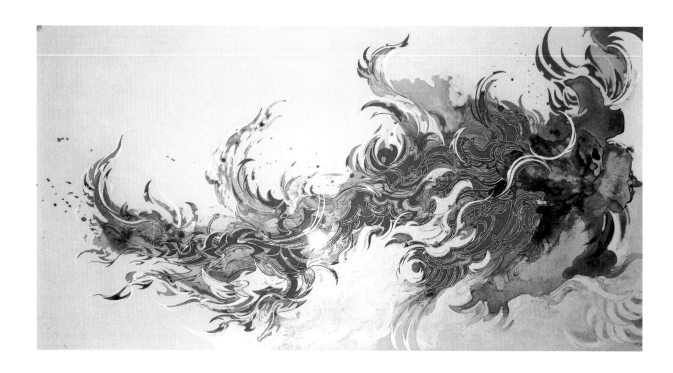

installation was overwhelming. The time-lapse Motion Paintings films were one of the most interesting collaborations for me, especially when three or more artists were painting simultaneously. You could see the streaming effect of the styles merging, the transformation from individual style. It also documented the personal artistic growth of the artists involved throughout the five films.

I am not too certain about the development of street or guerilla art with artworks selling for vast sums of money. I can't say I am coming from where these artists are. I wouldn't assume nor have I done works on that level. But trying to judge if it is good or bad is bullshit. The nature of some artists or their artworks is to proliferate in public spaces. It's just another venue, medium and canvas. If works that were primarily displayed on the streets then transpose themselves into galleries and museums, then the dialogue would be for the artist himself to reflect that particular transition through his work. Artists should not be reproached for understanding and using the mechanisms of capitalism. To be held to this idealistic notion that art should be created in a purist fashion outside the conditions of this reality, devoid of any monetary motivations or influences – that's retarded. Bending perceptions of what is the norm, infiltrating the art market like some of the artists did, intentionally or not – that's tremendous and they should be pissing themselves laughing. Artists have been provoking our senses and minds in so many ways – culturally, politically, socially, aesthetically. The real and only question for us should be if the works are shitty or not.

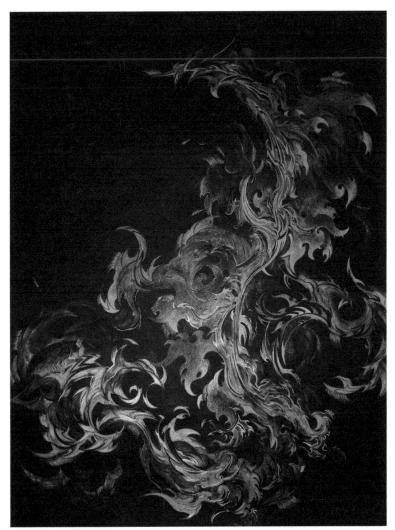

This spread – *Three works by Che Jen (above):* White *(opposite),* Rise *(top) and* Tropic *(right).*

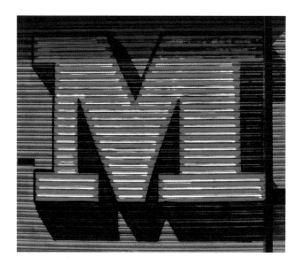

ike
Ming

Mike Ming was born Michel Miyahira in Flushing Meadows, New York in 1972. This founding member of the Barnstormers street art crew graduated from the Rochester Institute of Technology with a BFA in illustration and was soon leading art projects and working on books, drawing on such aspects of popular culture as skateboarding and surfing. From the beginning his use of vivid colours and psychedelic depictions of the ocean and wider forces of nature made him stand out as an artist.

His first book *Let's Go For A Drive* made him a household name in Japan where he held a series of big solo shows ('Free From The Road', 'Surf Journals', 'Repro-Frenic' and 'Mike Ming'). Of his many corporate projects, Mike's designs for the Dell Art House Special Art Edition series of laptops is the most widely recognized. He has also worked with Calvin Klein, H&M, Sony Music Japan, Gravis Footwear and Giant Step, the New York record label that invited the Barnstormers to their regular club night, merging music and street art..

In today's guerilla art world, the laid-back, peace-loving Mike Ming is a unique visual negotiator.

www.mikeming.com – Interview Christian Fussenegger

Opposite – *Several of Mike Ming's recent works.*

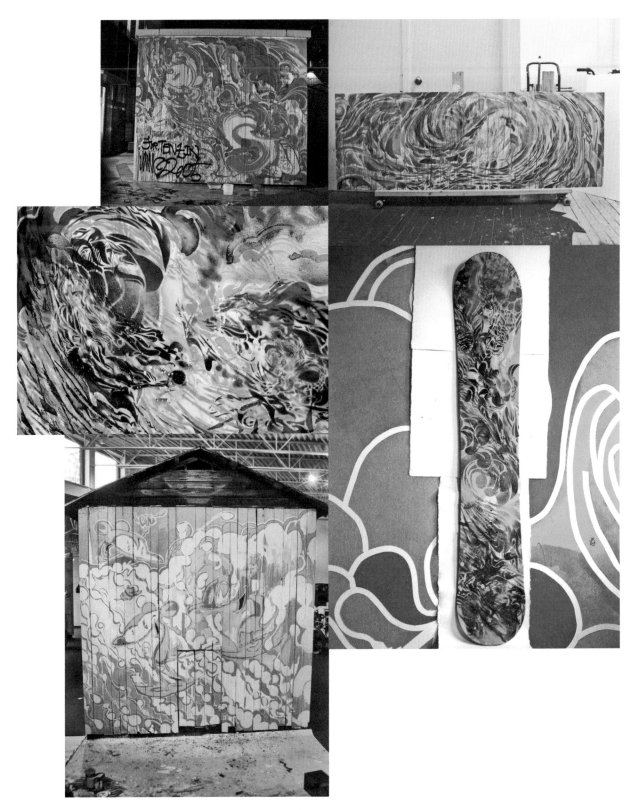

The reason why 'Barnstorming' started and why it keeps going, is that we want to travel to different parts of the world and spread some art around and collaborate on different visual ideas. We all have a respect for art, we all really love art. We just want to be put in a situation where you express yourself creatively without any hindrance, without anybody holding you back. We want to do as much, with as much space, in as little time. It's also about the group dynamic. We are like brothers and sisters – it's one big family. The community aspect, that's how it was back in the

day when you went to the campfire and brought whatever you could to the table so that everyone could have a meal. That's Barnstorming for me.

Barnstorming came from us looking at each other's work, having gone down to North Carolina, and developing relationships based off of getting to really know who individuals were. We came to have an idea of what it was that someone might draw out or where they were heading in their thinking. It's a lot like listening to a jazz piece and looking at the music sheet – you can't believe that it's only four or five bars long, but

then when you hear them playing it for thirty minutes, you realize they are all going through certain patterns. It's just like that – everyone's got their pattern, you just have to be able to read it, join in right on point while it's moving. It's improvisation to me.

The whole thing progressed when we went to the Giant Step night and started doing live painting. We called up the cats that were involved in Barnstorming at the time and got a small group together. They didn't really expect to have five people come on-stage – they really only wanted one or two to spend an hour

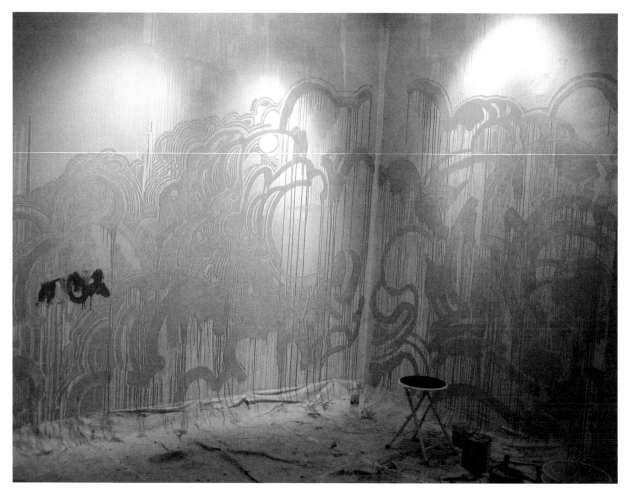

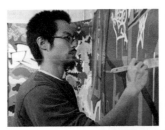
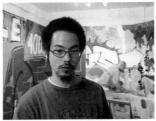
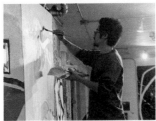
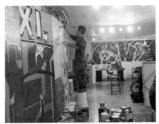
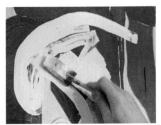
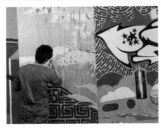

Opposite – Mike Ming's Wave Wall *installation.*
This page – Mike Ming in his New York studio preparing for a
Barnstormers exhibition.

doing a small canvas, but with the five of us, it just made it more dynamic. An amazing piece looked like it was created by one hand although it was touched by five. Everyone had their own energy and their own idea of what they wanted to paint. Most times we'd talk about what it was we wanted to accomplish, but for me, the greatest moments came when we did the least amount of talking and just attacked it. Everyone worked on top of each other, underneath each other, hand coming through legs. That's what made it work at Barnstorming. We did a lot of different projects – clubs, streets, city, outside, wherever – it was about the creativity.

Music is a really important part of the artwork. Music can help either bring out whatever it is you might have in your mind or it can really go against what you are doing. Sometimes that happens. You want to paint a certain way, but then you hear music and it's really distracting, more like noise. With Barnstorming, we found we could paint together no matter what the situation. It makes me feel confident knowing we can all do that and have an understanding of each other. In clubs, people are just out to have fun, but I think we were an extra part of the entertainment – you're dancing, you stop for a second, look around the club and notice some cats doing something new.

Next time you look, you see something completely different. To me, that's entertainment, that's something visual – beyond looking at all the girls.

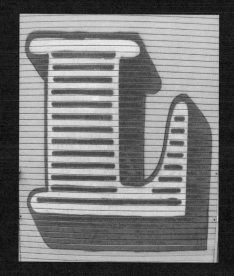

azarides

Steve Lazarides is the original barrow boy of the UK guerilla art scene. The man, who started selling artwork out of his car boot, single-handedly put artists like Banksy on the contemporary art map – first by revolutionizing the sale of limited-edition prints with website collective Pictures On Walls (POW), then by becoming Britain's premier gallerist for a new generation of street art-inspired artists. In 2006, Steve opened his first gallery, Lazarides. He now runs a couple of other spaces in London and Newcastle, representing a growing stable of artists, including Banksy, Faile, Mode 2, Paul Insect, 3D and Zevs.

Steve Lazarides' early passion for photography became a job when he worked as photo editor for the now defunct *SleazeNation* magazine in London. During this time he first met fellow Bristol boy Banksy. Immediately the two struck up a creative friendship and since the late 1990s Steve has been the 'official' photographer documenting Banksy's stencil adventures. Together they also set up the on-line print sales site Pictures On Walls, which soon became one of the primary sources for prints by various street artists. The POW collective continues to run alternative art events for the growing street art community such as Santa's Ghetto and the London Cans Festival in 2008.

www.lazinc.com / www.picturesonwalls.com – Interview Goetz Werner

Opposite – Faile, NYC Forbidden Love, *2006* .

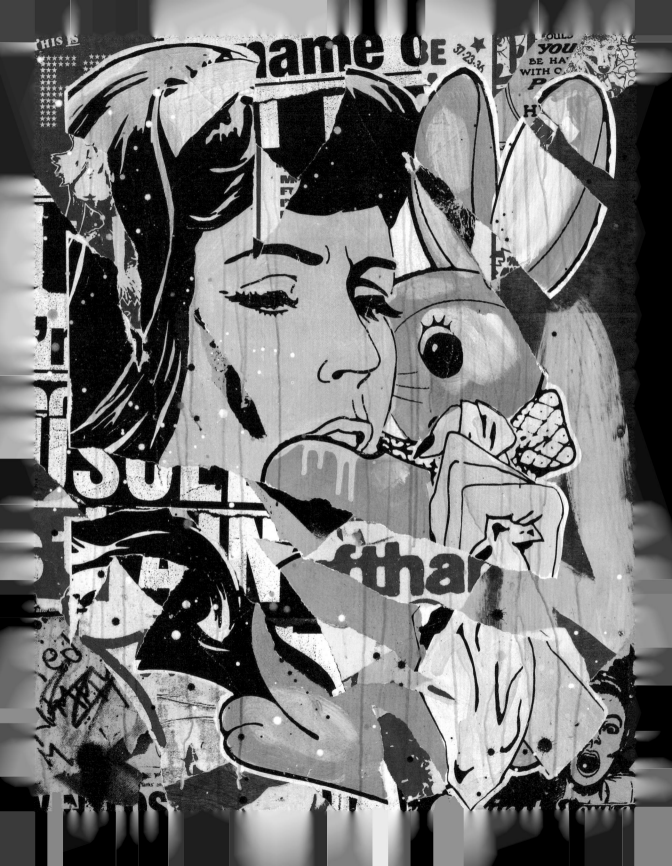

The Lazarides gallery presents some of the most acclaimed guerilla artists in the world, and is also known for putting on the best exhibition launches in town – including a private auction in a Soho strip club, or taking over the favourite drinking haunts of Princes William and Harry for the rowdy after parties of the 'Royals of Street Culture'.

When I was about fourteen I really got into graffiti. I used to travel into Bristol on the bus to look at 3D's pieces and then I was in college with a guy called Inky. Back in the late 1980s we used to travel up to Barton Hill youth club to take pictures. So it has been a lifetime passion. When I was working as a photographer and did the picture agency PYMCA, the meeting with Banksy was important; we started Pictures On Walls when it all really kicked off. It used to take at least a year to sell an edition of Banksy's prints. Now it takes seconds. But it's not just him. If you put a new Faile print up, you maybe sell 250 prints in 20 seconds. Those prints are a bit like Wimbledon tickets; I think POW started it. You would sell something for £150, knowing full well that the next day that print would be worth ten times what you charged for it. But the whole idea was to keep the prices down and make the prints affordable for everyone.

We had been going around seeing a lot of the artists and I don't think any of them ever really had the confidence to sell their artworks as an original.

Selling originals started in early 2000 because it began being seen as 'proper art'. It's important to keep pushing the boundaries, otherwise it gets boring. No one wants to see the same shit all the time and the last thing anyone wants to see in the gallery is any traditional style of graffiti. What you really are looking for are innovators; that's what Banksy was in a big way, and all the new guys I am working with – people like Blu, JR and this guy called Bast. They are amazing. Zevs from Paris, Invader, Jonathan Yeo, Antony Micallef, Faile – none of them has gone the traditional route, and that's the same with me. I have never had any traditional training within the art world. I didn't do a degree or whatever. All my artists are outsiders.

This page – 3D, How to Sneak a Bomb into a Gallery, *2008 .*
Opposite – *Mark Jenkins*, Our Lady of Anarchy, *2007.*

You have got two art worlds running side by side; it's our art world and then their art world. And even though you are selling to the same clients, sometimes for similar amounts of money, you know you can take people like Banksy and Faile and Barry McGee and some others anywhere within the contemporary art market. As you nurture artists, you certainly don't see a lot of the bigger galleries like White Cube trying to jump on this bandwagon because I think they understand that they don't understand. They are quite happy working with the kind of artists that they work with. I also don't have a problem with the auction houses. Sotheby's and Christie's are a bit like a good art gallery. I think they go into it to build an artist's reputation. It's not in their interest to bring the prices up really high and then have them crash the next day. What they are looking for is to extend an artist's career. It is more a problem with the secondary market galleries. They couldn't give a flying fuck about the art as far as I can tell. Sell it this week and if next week Nazi art is involved, then they will be selling pictures of swastikas. I don't think they really give a shit one way or the other about the art. And then they are also doing it with artists that really don't warrant the kind of prices they are asking for, so suddenly any new artist has to cost £5,000 to £10,000; this is a new phenomenon. Even 18 months ago you could buy a Faile canvas for £3,000.

There is a reason Warhol is remembered beyond just his pictures. He had the Factory, they did wild events. It was much more about the happenings and everything else. Aside from the art being great, he really entertained people. If you are inviting someone to look at something, there is more to it than just poncing around with a thin-stemmed wine glass in a white box with a concrete floor. It always depresses me when you see even galleries from within the scene trying to ape what the traditional galleries do. It's like 'Come on mate, have a bit of fucking fun with it, for God's sake'. I still enjoy doing shows outside of galleries as much as, and even more than, doing them in my own gallery.

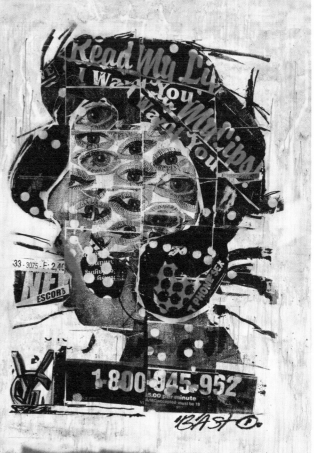

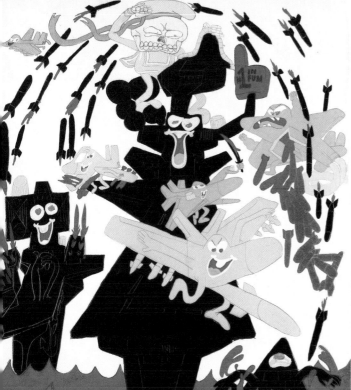

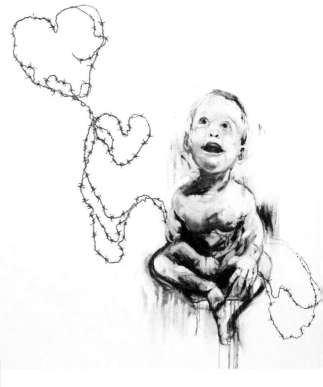

Our show in the strip club was great. You had the upper echelons of the contemporary art world – like all the big buyers. There were about four billionaires in the place. Dennis Hopper was there and a lot of the music people. It was an unbelievably broad spectrum. We had the world's worst strippers and the world's best art. We didn't plan it that way with the strippers, but they were so bad that people thought we did it on purpose. We also mixed the traditional old-school with something a bit odd. We got Lord Hinckley, who auctioned Vincent van Gogh's *Sunflowers* when it went for this ridiculous amount of money. He is the guy in Banksy's *I Can't Believe These Morons Buy This Shit* print. He is the auctioneer with the hammer, so we used him and he was totally up for it. He thought it was hilarious. Even by his own admission he was a little bit past it, but he had a great time and everyone loved it.

The zeitgeist has already been assimilated. Nothing stays underground forever and there is nothing wrong with that. Banksy's art is popular in the truest sense. The general population likes it. It's not just two people in an ivory tower saying: 'I'll buy it for a million quid'. It's hundreds and thousands of people saying, 'I like this, I want to buy a book, a sticker, a print or a canvas'. I do think that only a few people will break into the contemporary art world. Look at pop art, there were loads of them and how many are remembered now? In terms of graffiti and street art, you are talking three, perhaps four – mainly really Barry McGee and Banksy, but you'll really have to wait and see. The main thing is that a lot of the guys make a living as artists and are having a good time; surely that's what it is about.

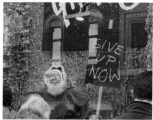

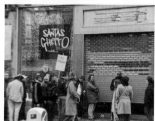

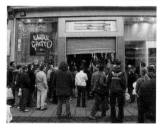
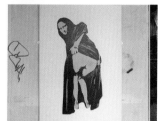

Opposite (clockwise from top left) – Paul Insect's Black Window *(2008)*, Bast's Read My Lips *(2008)*, Antony Micallef's Love Maker *(2008) and Reas'* 1 in Fun *(2008)*.
This page – The '2006 Santa's Ghetto' exhibition.

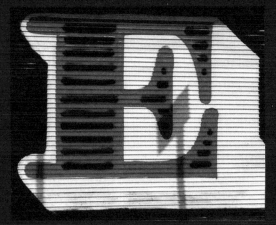

Ims
Lesters

Paul Jones set up his London street art gallery in the Elms Lesters Painting Rooms, which were purpose-built in 1904 for theatrical scene painting. Paul managed handmade scenic painting for large theatre and concert backdrops until the 1970s, when the Painting Rooms subsidized a gallery business that started with selling pop art prints by Peter Blake, Richard Hamilton and Howard Hodgkin. Over the following years Elms Lesters Painting Rooms dedicated its exhibition space to international street art, featuring solo and group shows with Delta, Futura, Stash, Phil Frost, José Parlá, Snug, Anthony Lister, Adam Neate, WK Interact, Invader, Kaws and Ron English.

www.elmslesters.co.uk – Interview Sebastian Peiter

Opposite – The Elms Lesters Painting Rooms with works on view by (clockwise from top) Delta, Anthony Lister, Futura, WK Interact and Adam Neate.

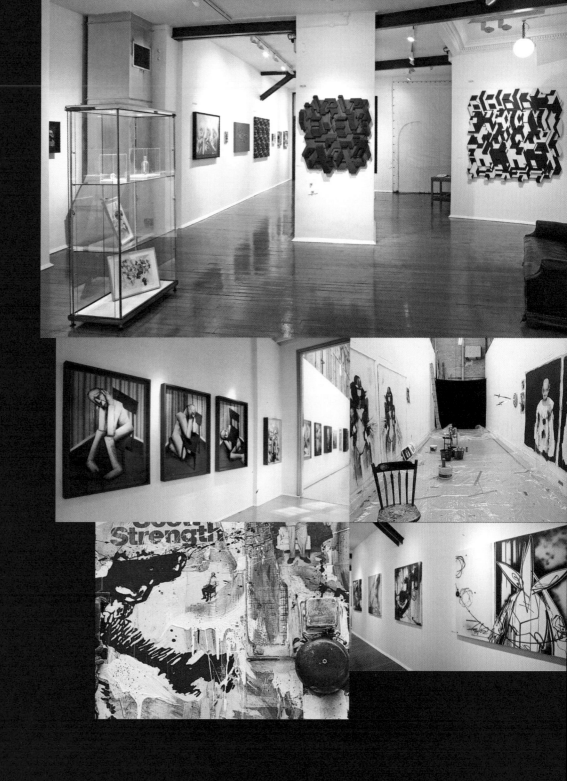

The Elms Lesters building has passed over from the scenic world of 1900 to the graffiti or street artists of 2000. I have Ron English coming in to paint something 40 foot long and 20 foot high (6 x 12 metres) for his show. They see the facilities; the frames go up and down. It has got everything that they could possibly use. It's like being on the street working. They feel at home here.

Most graffiti artists don't have any preconceived ideas, all they want to do is paint. They are just interested in painting better than the street artist next to them; to be able to do a finer line was one of the original things. They weren't thinking, 'I'll be showing in a gallery in 15 years' time'. Their heads were completely open, and that's why this is a movement

of different styles. Whereas, when pop art came in, or Dada, or anything, it was a very collective, college-based thing.

The basis of the street movement is marker pen, spray cans, household paint – it's anything that they can pick up and work with at speed, because they have to work as fast as they can on those walls before the police come along. There is more energy in their painting, more ideas. Their heads are entirely open because they haven't been funnelled by the critic or the college telling them what to do. I have artists here that are capable of getting into college, but didn't because they use spray cans. It was a Health & Safety issue. That's why there didn't used to be any spray-can artists working in colleges. They may have some now, they may have outside booths or something,

but I know an artist who was turned down by the Royal Academy; that's why the art stayed out in the streets.

The original people buying street art would buy something because they were brought up with names like Futura. They'd bought the T-shirt, they'd bought the trainers, they'd bought the poster and all of a sudden they were twenty-five to thirty-five, and they had a bit of money and wanted to buy a piece of art instead of having a T-shirt. They'd come in to buy a piece of art for £500 or a £1000, or whatever the price was, and they'd go home and were jolly pleased with their piece by one of their heroes. About 2002 was when the first people started buying in England, then each year you got a few more. Someone would go to their flat and see the piece and

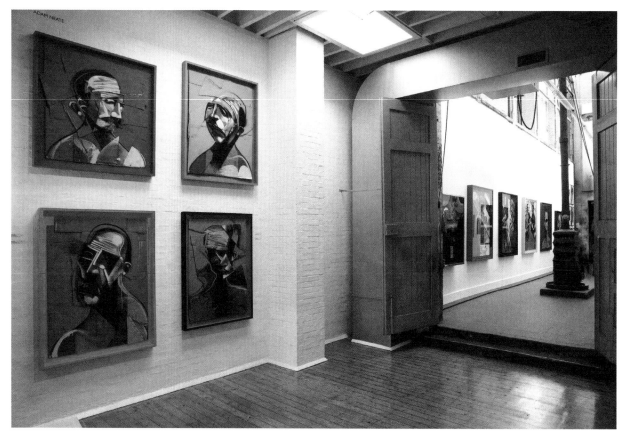

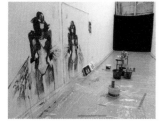
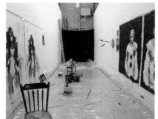
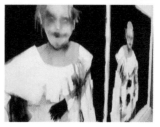

Opposite – exhibition of works by Adam Neate.
This page (from top) – Elms Lesters exterior, Space Invader mosaic, views of the interior spaces, Anthony Lister exhibition, WK Interact exhibition.

the Internet also started to come in, and it is now a big part of street art. All of a sudden it became viable as a gallery to sell street art because it was the art of the youth. In previous days they had their music, they had their clothes, they had their films, but they never really had art as a teenager. This time they have got their art as well. You have young people coming in here, sixteen, fifteen, fourteen year olds, talking about a painting for half an hour. Well that's never happened in the history of art.

This movement is still only just being recognized, with Banksy selling at those prices at Sotheby's. The art market does not pay in the hundreds of thousands for a piece of art unless they think it's correct; they are as hard-nosed as the City men who deal with stocks and shares. Most of the art world thinks it's a passing phase. They still don't think it's here to stay. Within any art movement you get maybe 50 artists worldwide who become successful in the mainstream, who are in national and big private collections. I would say the majority of street artists who are going to be successful are already there. It's been going for so many years now and there's only a few bumping in now; every year there are two or three. The next lot of people are just coming in really at the wrong time. A lot of the graffiti artists who are starting now, they have to have their own voice; they are the new kids on the block and they've got to produce different things to what's actually happening now – a different form of art.

gnès B

French Fashion designer Agnès B has been a lifelong arts patron. Since her early encounter with the first generation of artists who developed out of the graffiti culture in New York, Agnès has supported each successive generation of street-inspired artists via commissions for her fashion business, her extensive contemporary art collection or showcases at the Parisian Galerie du Jour Agnès B which she opened in 1984.

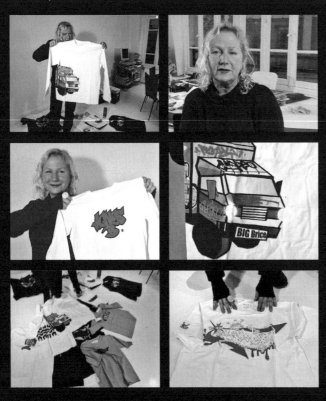

www.galeriedujour.com – Interview Sebastian Peiter / Thomas Raynal

This page – Agnès B with street art T-shirt commissions.
Opposite – Mist and Fafi pieces at the 'Graf Expo 2001' exhibition, Galerie du Jour, Paris.

I was born in Versailles. My father was very cultivated; he loved art very much. I started to appreciate art from an early age – he took me to Italy when I was twelve. I started to design clothes by chance – originally I wanted to work in an art museum.

By 1979/1980 I was already aware of the graffiti in New York. In the early 1980s the Lower East Side and Bowery were inhabited by artists and the homeless. New York has really been cleaned up; those cleaned-up places where people now play basketball were once covered in graffiti. It is in this area that Jean-Michel Basquiat used to live. Basquiat and Keith Haring were both street artists. It was around 1981 or 1982; I remember walls and subway posters by Haring. I remember Basquiat's tag. I met them both; they were lovely people. Basquiat was extraordinary. I

had many chats with him. I think he was one of the greatest American artists of the twentieth century. Before he died everybody was saying he was a junkie, he was finished, he was rubbish, and after his death his work became very expensive. You don't get a Basquiat or Keith Haring every day, but I think there are a lot of very talented people to be discovered in the streets today.

There was no turning point where I said, 'Today I am going to collect contemporary art'. I started by tearing up pieces of posters in the streets, and keeping postcards. One day when an artist gave me an artwork, I realized that I could buy pieces from artists who were just starting out. When you work with young artists, buying pieces is a way to say, 'Continue'. How can you define where art starts and where it ends? For example, when I take a photograph of what I see on

the streets, depending on how I frame it, it can suddenly be artistic. Art can just start by the impression you receive. According to the writings of the eighteenth-century encyclopaedists Diderot and d'Alembert, beauty is defined as all feelings of agreeable relations. I think it's a beautiful description of beauty. An artist passes on his vision of beauty, of what he has to say – that's what art is. It is visions and feelings at the end of the day.

When I opened my first Agnès B boutique in Paris, I put some artwork up to see if people liked it and to please them too. It is amazing to share art with other people. It's a way of exchanging thoughts. This is how my art collection started, step by step, with a lot of work from graffiti artists and many others. I opened my gallery in 1984, where I started to show Les Ripoulains, who

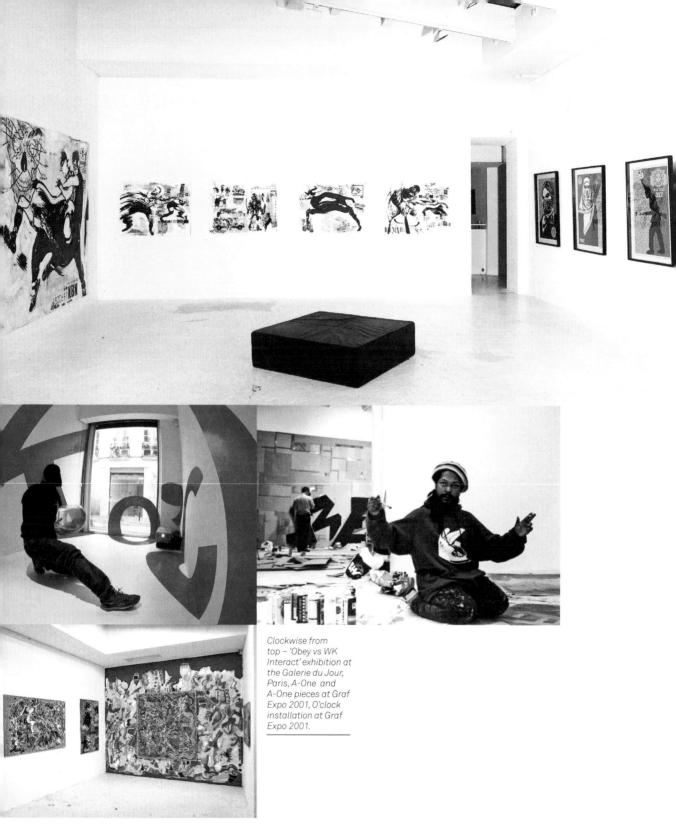

Clockwise from
top – 'Obey vs WK
Interact' exhibition at
the Galerie du Jour,
Paris, A-One and
A-One pieces at Graf
Expo 2001, O'clock
installation at Graf
Expo 2001.

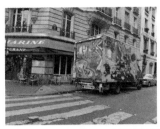

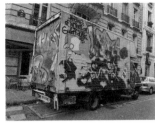

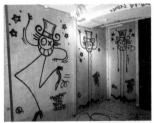
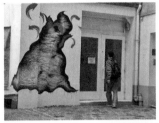

From top – The Agnès B delivery van, André at Galerie du Jour, the gallery exterior, canvases, street art hat commissions, Agnès' company car.

were street artists, and also Claude Closky and Pierre Huyghe.

There is a different generation of graffiti artists every five to ten years. I have always been close to this movement – the squats they used to inhabit, the northern suburbs of Paris where they paint. And where I used to go to watch them paint. I would go with Vincent Segal, a cellist and great friend whom I met through Futura. There is also the music, the hip hop. Everything is connected because it's a movement that crosses borders. They set themselves challenges in Denmark, Germany or Italy. I have just filmed in an amazing deserted factory near Padua with walls covered in graffiti, which was wonderful. The styles change very fast. Since I have known it, it's an art form that is always moving. The tags have evolved. Suddenly somebody does a new technique. There were the spray cans used on trains, then came bigger and bigger markers and then you had the metallic style next. The lines were straighter, then bendier. It has completely changed since 20 years ago. Everyone has their own style. I think that graffiti art does not always transfer

to canvas. They are very free on walls but feel locked up by a canvas and a bit lost. But each artist is different; that's what makes it beautiful. I have got great pieces from Futura dating from 1989, 1990, 1991 and 1992. Rostarr is a really good artist too; he makes beautiful paintings. I can't give more names because there are so many – A-One, Jonone, Ryan McGinness – they are artists who will become big as well.

When the artists talk about their work, they want to create something beautiful. You shouldn't mix up an artist's piece on a white suburban wall with vandalism; it is completely different. People should be happy that they have some art work done in their neighbourhood. We should make them see it in a different way. Does your naked and grey wall really look more beautiful plain than it would with a painting on it? It's not about picking a legalized space where they can paint; that does not work. It's about making people admit that graffiti art is interesting and beautiful and not something that pollutes. There is a lot of work to do.

My life has been influenced by lots of different things, of course, but mainly by the graffiti world. I have always liked it. It's been over 20 years! I have even seen graffiti on a trunk in the park of the château of Versailles. It's the act I am interested in as well, not just in the art created. There is a need to express yourself on a wall. Since the beginning of humanity, there is this need to mark your territory. To leave a trace is part of human nature; it's an old tradition. Today it is considered vandalism, so there is a lot of work to do to make the graffiti world heard and understood. That is why I fight a lot for my friends – some are in jail, some are on trial. I was talking to Tony Negri who spent 25 years in jail in Italy. He was saying graffiti has replaced the political slogans people used to put up; now it's the act of the graffiti artist that is political. The posters during the May 1968 revolution in Paris were beautiful and they were made very quickly. I was there at the time. I have not changed, I am still left-wing, I am still outspoken when I am angry about something and I get angry when things touch me. It is very political to write on the walls. That's what I like.

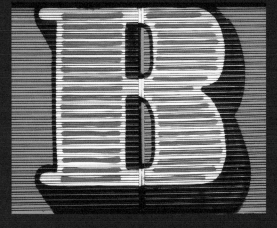

ackjumps

After publishing two editions of the street art magazine *Backjumps*, the Berlin-based Iranian-German publisher Adrian Nabi decided to continue his print magazine as a three-dimensional exhibition project showcasing the most innovative crossover work from street artists around the world. Backjumps' 'Live Issues' have brought Banksy, Swoon, WK Interact, Delta, Lokiss, Akim, os gêmeos and Shepard Fairey to Berlin. A 'Live Issue' has even been held in Tokyo.

Today, street art as a phenomenon makes its mark on urban landscapes the world over. Surrounded by hype, and positioned between the artists themselves and their critics, the intermediaries of the art form, like the organizers of the 'Live Issue' exhibitions, must carefully and faithfully present the works. And they must do this even though such sensitivity seems lost in the face of guerilla marketing and an established art world, which for the most part lacks the credentials or inside knowledge to judge the movement and its activists. To this end, *Backjumps* has given itself the responsibility of communicating background knowledge of the scene, from where the street and the white cube meet.

Interview Sebastian Peiter

This page – Print and live on-line issues of Backjumps.
Opposite (clockwise from top) – City of Names cardboard city at 'Backjumps Live Issue #2' in Berlin; Swoon, Banksy, Maison Anti and Faile rooms at 'Backjumps Live Issue #1' in Berlin.

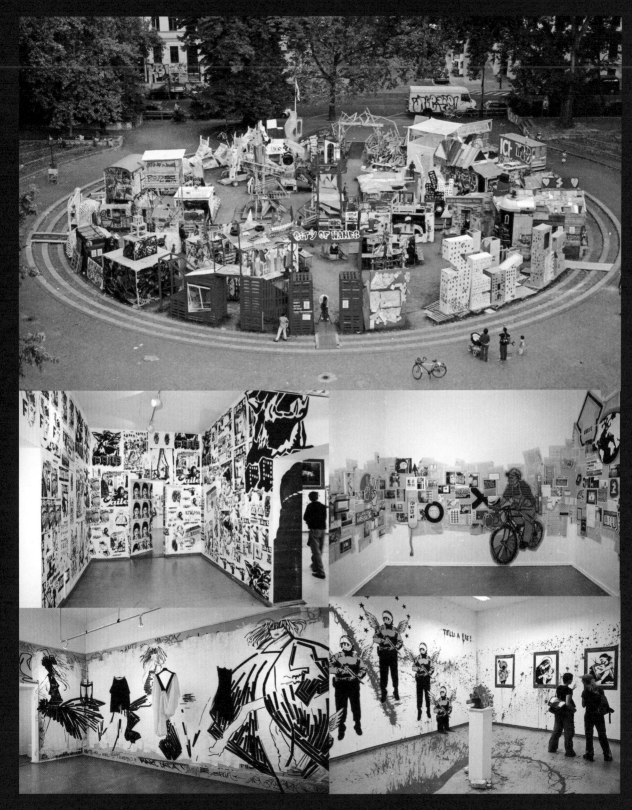

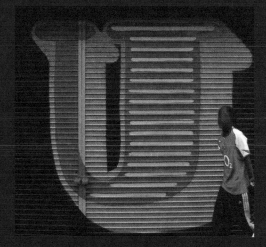

URBANATION

Most artists in *Guerilla Art* were originally filmed in their home cities as part of the *URBANATION* television series, covering underground youth culture from London, New York, Tokyo, Paris and Berlin. A kind of youth culture magazine, the series features urban art, street fashion, extreme sport, club culture, off-the-wall sightseeing and influential music artists Moby, P. Diddy, Beck, Groove Armada, Dillinja, Gorillaz, Air, Rammstein, Paul van Dyk, Beenie Man, Ken Ishii, DJ Krush and many more.

Produced by UK production and distribution company Urban Canyons, *URBANATION* was originally created by Sebastian Peiter and Damian Schnyder for Switzerland's public broadcaster SF and later shown by more than 20 broadcasters around the world, including Travel Channel, Current TV, National Geographic International, Discovery Asia, Zee TV, Globosat Brazil, Mediacorp Singapore, Canal+ Cyfra, C4 Nelonen and TBS Korea. The series was also picked up by adidas Instore, various airlines and was used for a *Time Out* DVD collection.

www.urbanation.tv

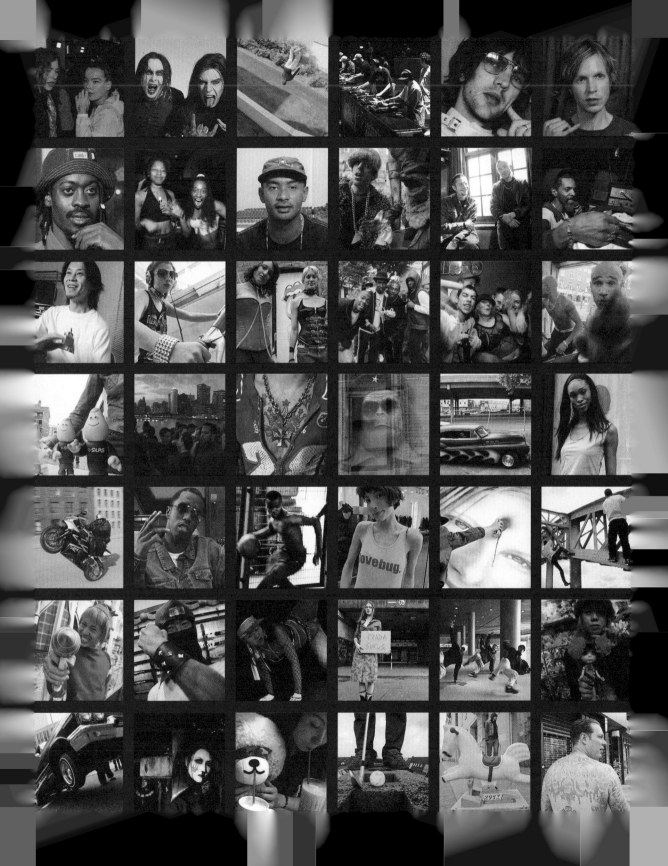

Ramm:ell:zee – Goetz Werner, thanks to Will Luckman and PictureBox; Futura –
Thanks to Marok from Lodown Magazine and Elms Lesters Painting Rooms; Blek Le
Rat – Sybille Prou, Sebastian Peiter; Banksy – Thanks to Pest Control, Sebastian Peiter;
Invader – Thanks to Invader and Orbi; WK Interact – Thanks to WK; os gêmeos –
Goetz Werner; Eine – Sebastian Peiter, thanks to Ben and Elms Lesters Painting Rooms;
Noki – J.J. Hudson & Sebastian Peiter, Olly Walker, thanks to Cube PR; André –
Thanks to André and associate; Zevs – Thanks to Aguirre; Miss Van – Sebastian
Peiter, Michael Anthony Barnes-Wynters, thanks to Galerie Magda Danysz, 2007 Atame
exhibition; David Ellis – Jimmy Fontaine, thanks to Keppie at Roebling Hall; Che Jen
– Thanks to Che; Mike Ming – Thanks to Mike; Lazarides – Thanks to Steve Lazarides;
Elms Lesters Painting Rooms – Thanks to Paul and Fiona; Agnès B – Marc Poletti,
Laura Morsch, thanks to Galerie du Jour; Backjumps – Thanks to Willem Stratmann and
Adrian Nabi; All screen grabs from Guerilla Art documentary © 2008 Urban Canyons Ltd.

DVD CREDITS:

Artists: Futura, Ramm:ell:zee, Mike Ming, Espo, Blek Le Rat, Banksy, Invader, os gêmeos,
David Ellis, Che Jen, Alex Lebedev, WK Interact, Eine, André, Noki, Miss Van, Zevs

Thanks to: BALTIC Gateshead, Jerôme Sans, Pictures on Walls (POW), Galerie Du Jour,
Elms Lesters Painting Rooms, Kemistry Gallery, Sotheby's, Michael Anthony Barnes-
Wynters, Adrian Nabi, Denise Proctor, Damian Schnyder

Photography: Colin Davison, Don R. Karl, Sybille Prou

Voiceover: Tim Marlow

Sound Studio: The Bridge, Tim Cullen

Title Graphics: Ben Eine, Nick Walker

Editors: Sebastian Peiter, Kanwaljeet Thind, Len Davies, Donald Takeshita-Guy

Insert Directors: Christian Fussenegger, Denise Langenegger, Damien Saracin,
Eva Sonaike, Markus Storrer, John Wate, Goetz Werner

Camera: Michael Linehan, Robbie Anderson, Robert Christiansen, Mark Cullen,
David Hicks, Dan Laloum, Jay Palit, Paul Teverini, Marc Williamson

Music: Stereo MCs: Breathe Out, Out Of Control – 2005 Graffiti Recordings; Klute: Does
the Darkness Make You Feel Sad?, Make a Stand, 6 Days, I'll Do Anything, Acid Rain,
No Return – 2005 Commerical Suicide; Psidream: Identity – 2002 Breakbeat Science
Recordings; Pieter K – Numina, Impressions, Natural Light (remix), It Could Have Been
You, Un Amour Fou; Dune: Oracle – 2002 Breakbeat Science Recordings; Leisure
Centre: Serpant Woman, Regazzi Gangster – 2007 Matt Dolen

Producer/Director: Sebastian Peiter, URBANATION.TV 2008

Produced and distributed by Urban Canyons Ltd